Lutz Heusinger

MICHELANGELO

SCALA/RIVERSIDE

CONTENTS

The illustrations for this volume come from the SCALA
ARCHIVE, which specializes in large-format colour
transparencies of visual arts from all over the world.
Over 50,000 different subjects are accessible to users by
means of computerized systems which facilitate the rapid
completion of even the most complex iconographical
research.

© Copyright 1989 by SCALA, Istituto Fotografico
Editoriale S.p.A., Antella (Florence)
Layout: Fried Rosenstock
Translation: Lisa Clark Pelletti
Photographs: SCALA (A. Corsini, M. Falsini, M. Sarri),
except: no. 1 (Munich, Graphische Sammlungen); no. 2
(Vienna, Albertina); no. 17 (London, Royal Academy);
nos. 24, 71, 91 (London, British Museum); nos. 26, 27,
28, 29, 30, 31, 32, 33, 34, 35, 36, 37 and back cover
(Vatican Museums); no. 59 (Leningrad, Hermitage);
no. 77 (Boston, Isabella Stewart Gardner Museum)
Produced by SCALA
Printed in Italy by Lito Terrazzi, Cascine del Riccio
Florence 1994

Cover:
David, detail (Florence, Galleria dell'Accademia)

Back cover:
*Detail of the Azor-Sadoch lunette with the
presumed self-portrait of Michelangelo (Vatican,
Sistine Chapel)*

Michelangelo Buonarroti

Michelangelo lived and worked for nearly a century: he was born in 1475, was apprenticed to Domenico Ghirlandaio in 1488 and worked continuously until six days before his death, in 1564. It was during these turbulent years that the medieval aspects of the Christian religion were swept away, especially by the violent surge of the Reformation; that the Polish astronomer Copernicus revealed to his contemporaries the true position of the earth in a heliocentric system; that men liberated themselves from the ways of thought of medieval Scholasticism to become spiritually free and independent individuals. No other artist managed, as Michelangelo did, to portray this change in his works, and no other man lived this change as intensely as he did. "But he who bears the palm from all, whether of the living or the dead; he who transcends and eclipses every other, is the divine Michelangelo Buonarroti, who takes the first place, not in one of these arts only, but in all the three. This master surpasses and excels not only all those artists who have well nigh surpassed nature herself, but even all the most famous masters of antiquity, who did, beyond all doubt, vanquish her most gloriously: he alone has triumphed over the later as over the earlier, and even over nature herself . . . ".

Giorgio Vasari, contemporary and friend of Michelangelo's, described him like this. Through his words of praise we can discern the major trends and objectives of the period we call Renaissance, and those of its later artistic form, Mannerism. Artists, philosophers and princes, each in his own field, began to contribute to the expression of a perfect terrestrial reality. They represented it as spiritually independent, standing in opposition to the supernatural or divine reality, upon which all medieval values had been based. These ideals of earthly perfection found their only precedent and model in the actions and works of the Classical masters. Thus, in all spheres of life, the Renaissance man tried to imitate the ancients, to accomplish once more the deeds of their heroes and to adopt their most typical qualities.

Michelangelo was born on the sixth of March, 1475 at Caprese, in Tuscany, the son of a civil servant of low rank. Part of his childhood was spent in Florence, part in the family country house outside the city. When he was six years old his mother died. For many years Michelangelo virtually boasted of the fact that his family had belonged for centuries to one of the uppermost classes of the city, according to their registration with the census. However, pursuing Platonic ideals, he never lived flamboyantly, never married and, unlike most of his contemporary fellow-artists, never tried to better his social position. For the best part of his life he cared above all for his father and his four brothers; it was only for a short period of time that, already in his sixties, he began to give importance to serious friendships, such as his relationship with Tommaso Cavalieri and Vittoria Colonna.

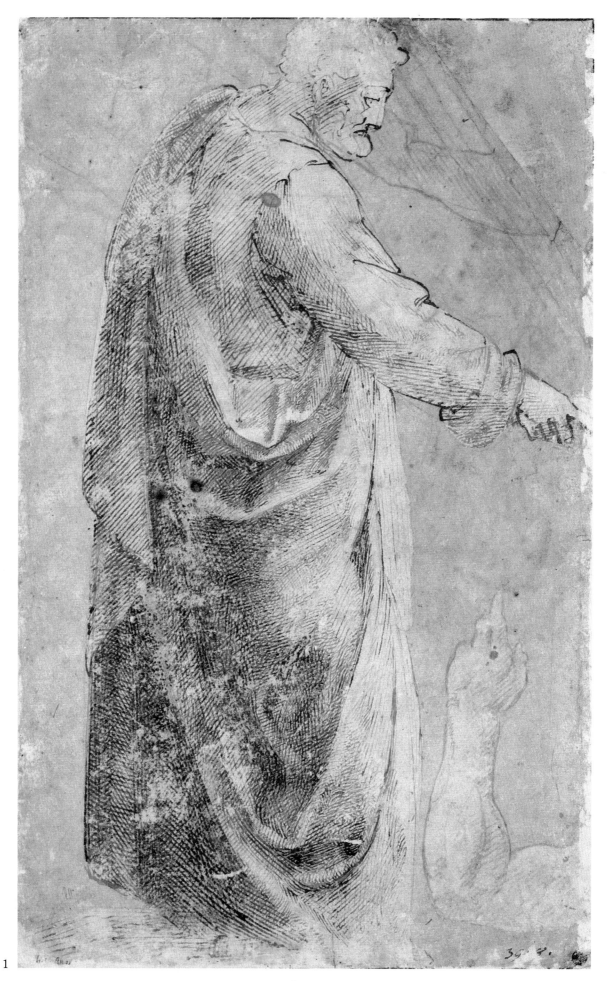

1

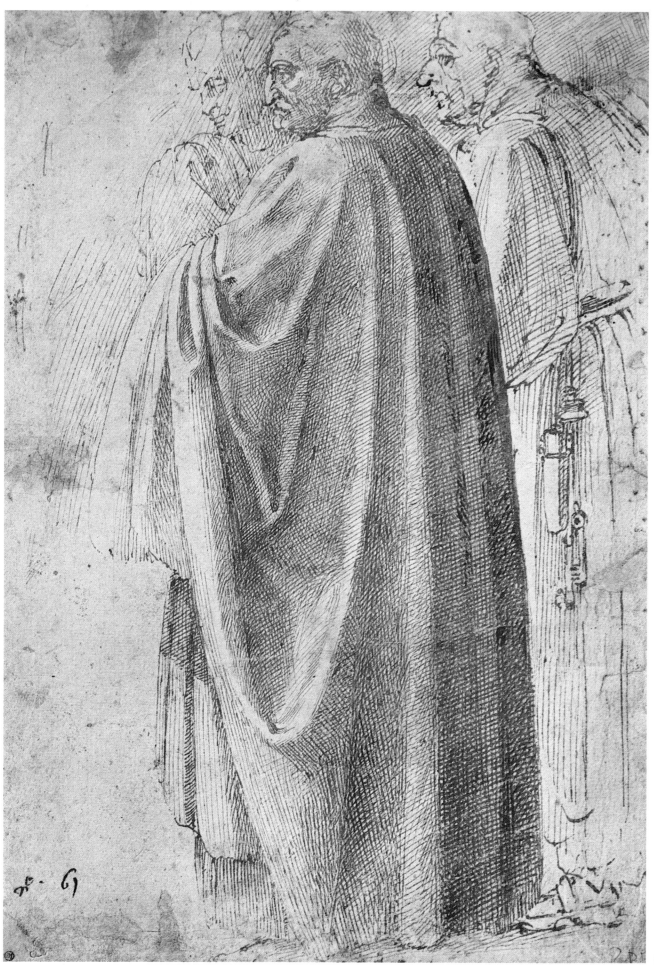

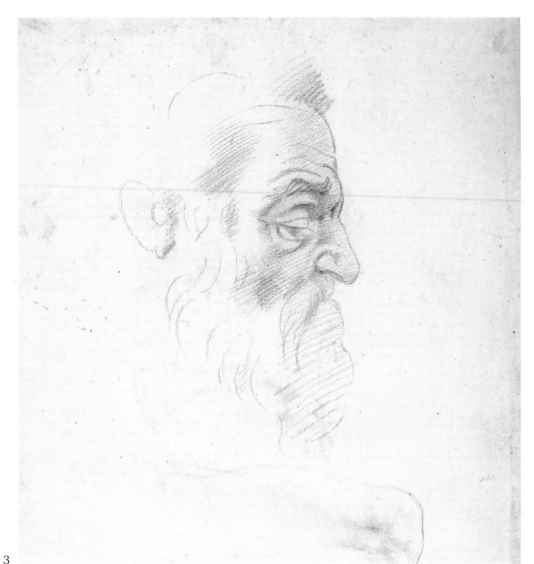

3

Early period in Florence: 1475-1494

In 1488, when Michelangelo was 13 years old, his father apprenticed him to the *bottega* or workshop of the celebrated painter Domenico Ghirlandaio. But the following year Lorenzo de' Medici summoned him to his court and allowed him free access to his gardens, where the supervision of the precious collection of classical statues had been entrusted to the ageing Bertoldo di Giovanni, former pupil of Donatello. More or less teaching himself, the boy mastered the technical skills essential to his craft. He fashioned clay and practised drawing by copying earlier works, such as the Masaccio fresco of the *Tribute Money*, showing with what certainty of intuition he was able to choose those works which would help him develop his innate qualities.

In those years Lorenzo's circle was composed of the most famous poets, philosophers and artists of the time. One could believe that this environment had a strong influence on the boy, although it is difficult to assume that he ever seriously took part in this intellectual community. However, the two bas-reliefs created during this period persuade us of the contrary. The suggestion for the relief representing the *Battle of the Centaurus,* a subject taken from Greek mythology, probably came from Poliziano, who might have read and translated the corresponding literary passages to the young sculptor. The only essential element in this primordial combat is the naked human body, caught in moments of utmost strain or of perfect feminine beauty. Everywhere, round and swollen shapes rise up, moving out of the ground, one by one, to overcut each other and then only to sink back down into the depths again. Even the rocks and the clubs, the only weapons the fighters are given, are rounded. No geometric order and not even the force of gravi-

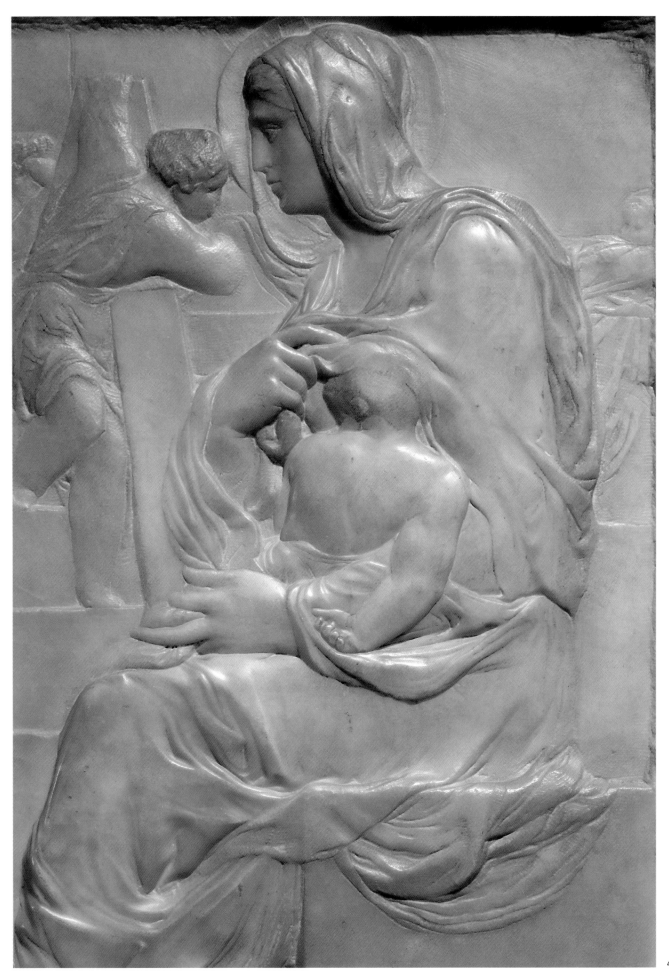

4

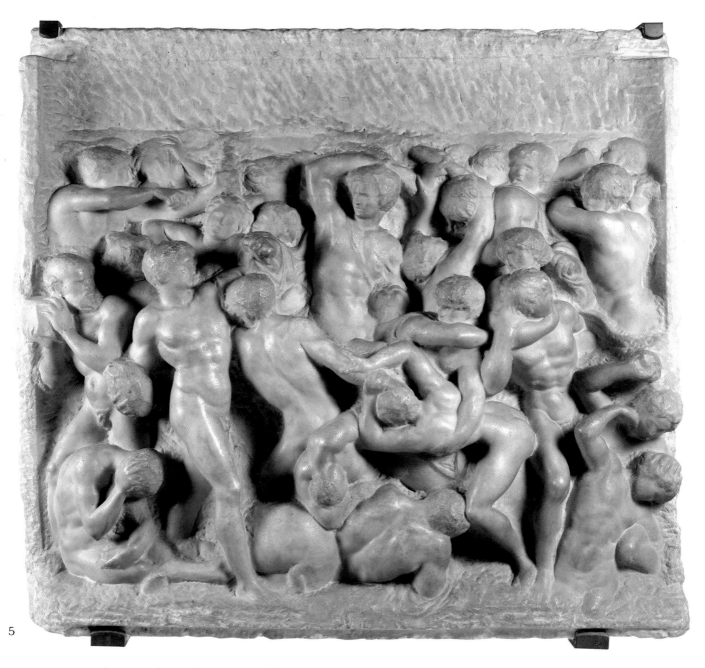

5

ty seem to rule over these figures and this action. Man alone with the strength of his body and the determination of his courage sets the terms of this chaotic struggle.

4 The representation of the *Madonna of the Stairs*, in its technique of the flattened relief, appears immeasurably different. On a smooth and flat surface of rock the Madonna sits serene yet monumental. She hardly seems to notice the Child curled up in her arms, taking her milk. Her intangible look, indifferent not only to the children on the stairs in the background but also to the onlooker, projects itself away onto something indefinable: it seems to gaze at a divine image. Here Michelangelo presents us with a "grand" human being, seen as an individual entity perfectly composed in its own right, while in the *Battle of the Centaurs* we had men in a deadly entanglement struggling for the posses-

5

sion of women. The sixteen year-old artist thus portrayed the two extremes of human experience and all this with a single means of representation: man and his body.

We learn from our sources that in 1494 Michelangelo presented the parish priest of Santo Spirito with a wooden crucifix: "in order to receive many favours from him, in order to be allowed a room to work in and bodies to study, for he could imagine nothing which would give him more pleasure."

Alas, we do not know this work: the crucifix 6 reproduced here is perhaps the one which, amongst all the ones handed down to us, resembles it most.

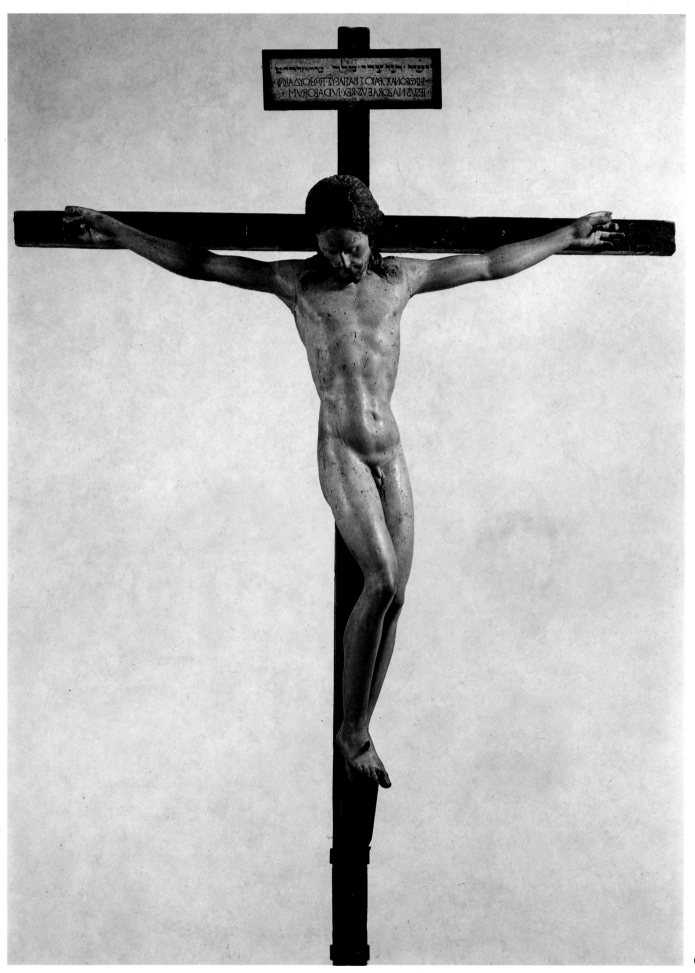

6

7

8

First success in Bologna and Rome: 1494-1501

At the death of Lorenzo il Magnifico in 1492, Michelangelo returned to his father's home. It was in that same year that Savonarola began his violent sermons in the Dominican convent of San Marco in Florence. Contemporary sources tell us how attentively Michelangelo read the writings of this fanatically religious monk and what an impression they made on him; in a letter written in 1498 from Rome he himself expresses his worries over the per-

ils the monk might run into. These worries were justified, since Savonarola was burnt at the stake a short while later. Not long before the French king, Charles VIII, drove the Medici family out of Florence in 1494, Michelangelo took refuge in Venice and later in Bologna, the Medici having been his patrons. In Bologna he received a commission from the aristocrat Aldovrandi to complete the *Tomb of St. Dominic*, which had been begun two centuries

7. Saint Petronio
h. 64 cms.
Bologna, San
Domenico

8. Saint Procolo
h. 58.5 cms.
Bologna, San
Domenico

9. Angel Holding a
Candelabra
h. 51.5 cms.
Bologna, San
Domenico

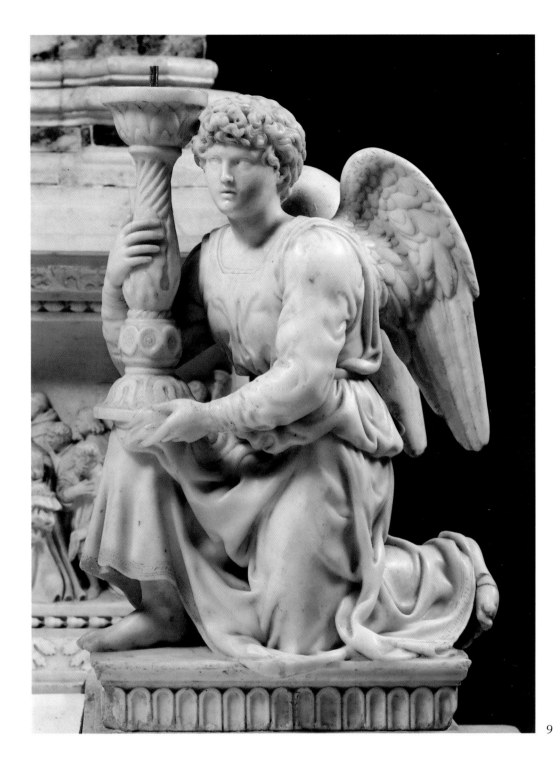

9

previously by Nicola Pisano's workshop. There were three statues still missing, representing the patron saint of the city, *Saint Petronius, Saint Proculus,* and an *Angel Holding a Candelabra.* Michelangelo cannot have been very much allured by this commission; yet these small statues, the first free standing works of his that we have, in the distribution of movement, in their powerful poses, and in the assurance of their shapes, anticipate the genuine passion of his later works.

At the age of 21 the artist went to Rome for the first time. We still possess two of the works he created in this period; others must have been lost for he spent five years there. The earlier one, a statue of *Bacchus,* was begun in 1497; it was commissioned by the banker Iacopo Galli for his garden and he wanted it fashioned after "the models of the ancients." According to a contemporary, it was a work "the form and aspect of which correspond, in every detail, to the intentions of the Ancients."

The body of this drunken and staggering god gives, at the same time, an impression both of youthfulness and of femininity. Vasari says that this strange blending of effects is the characteristic of the Greek god Dionysus. But in Michelangelo's experience, sensuality of such a divine nature has a

7, 8
9

11

drawback for man: in his left hand the god holds with indifference a lionskin, the symbol of death, and a bunch of grapes, the symbol of life, from which a Faun is feeding. Thus we are brought to realize, in a sudden way, what significance this miracle of pure sensuality has for man: living only for a short while he will find himself in the position of the faun, caught in the grasp of death, the lionskin.

In the *Pietà*, Michelangelo approached a subject which until then had been given form mostly north of the Alps, where the portrayal of pain had always been connected with the idea of redemption: it was called the *Vesperbild* and represented the seated Madonna holding Christ's body in her arms. But now the twenty-three year-old artist presents us with an image of the Madonna with Christ's body never attempted before. Her face is youthful, yet beyond time; her head leans only slightly over the lifeless body of her son lying in her lap. "The body of the Dead Christ exhibits the very perfection of research in every muscle, vein, and nerve. No corpse could more completely resemble the dead than does this. There is a most exquisite expression in the countenance. The veins and pulses, moreover, are indicated with so much exactitude, that one cannot but marvel how the hand of the artist should in a short time have produced such a divine work."

One must take these words of Vasari's about the

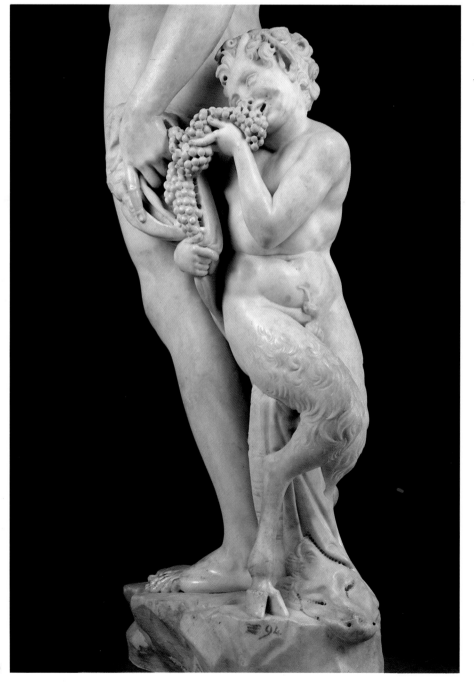

10. Bacchus
Detail of the faun
Florence, Museo Nazionale del Bargello

11. Bacchus
h. 203 cms.
Florence, Museo Nazionale del Bargello

10

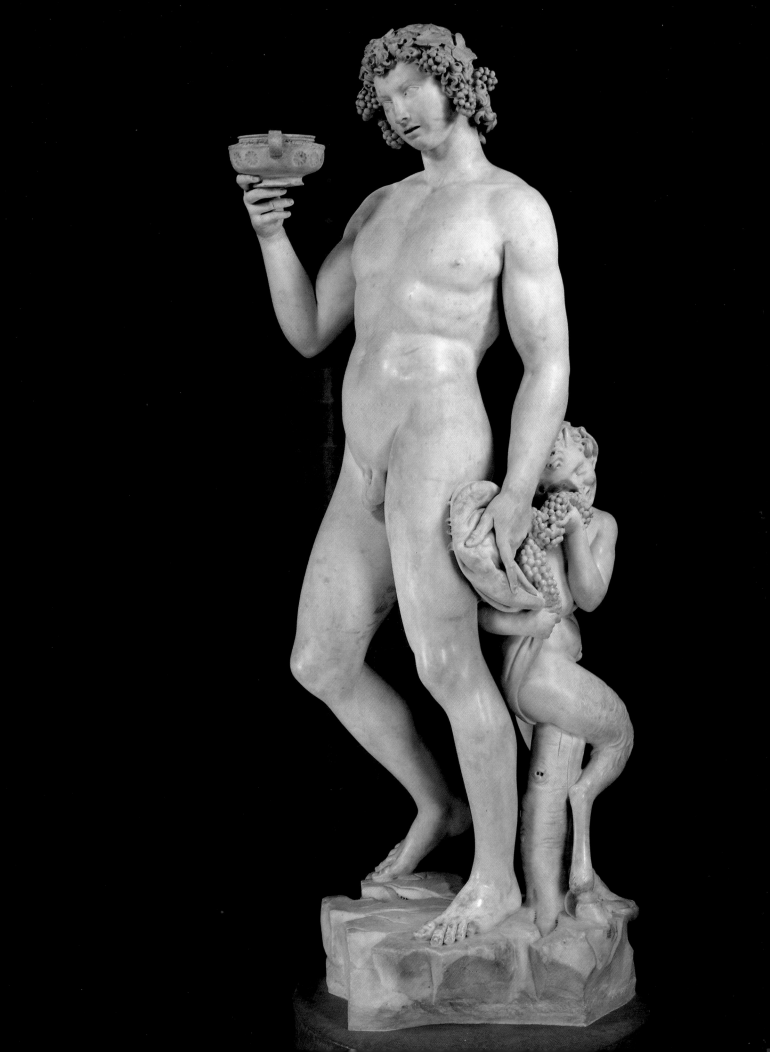

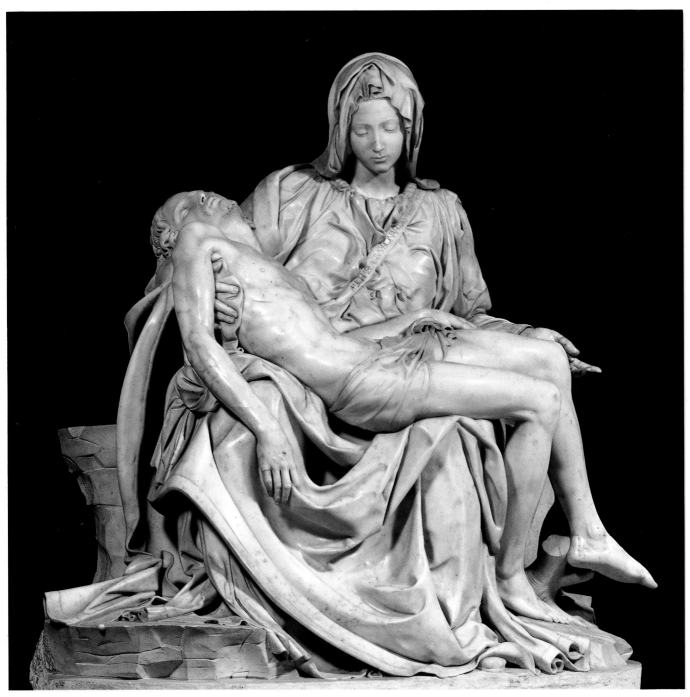

12

"divine beauty" of the work in the most literal sense, in order to understand the meaning of this composition. Michelangelo convinces both himself and us of the divine quality and the significance of these figures by means of earthly beauty, perfect by human standards and therefore divine. We are here face to face not only with pain as a condition of redemption, but rather with absolute beauty as one of its consequences.

12. Pietà
h. 174 cms.
Vatican

13. Pietà
Detail of the Virgin
Vatican

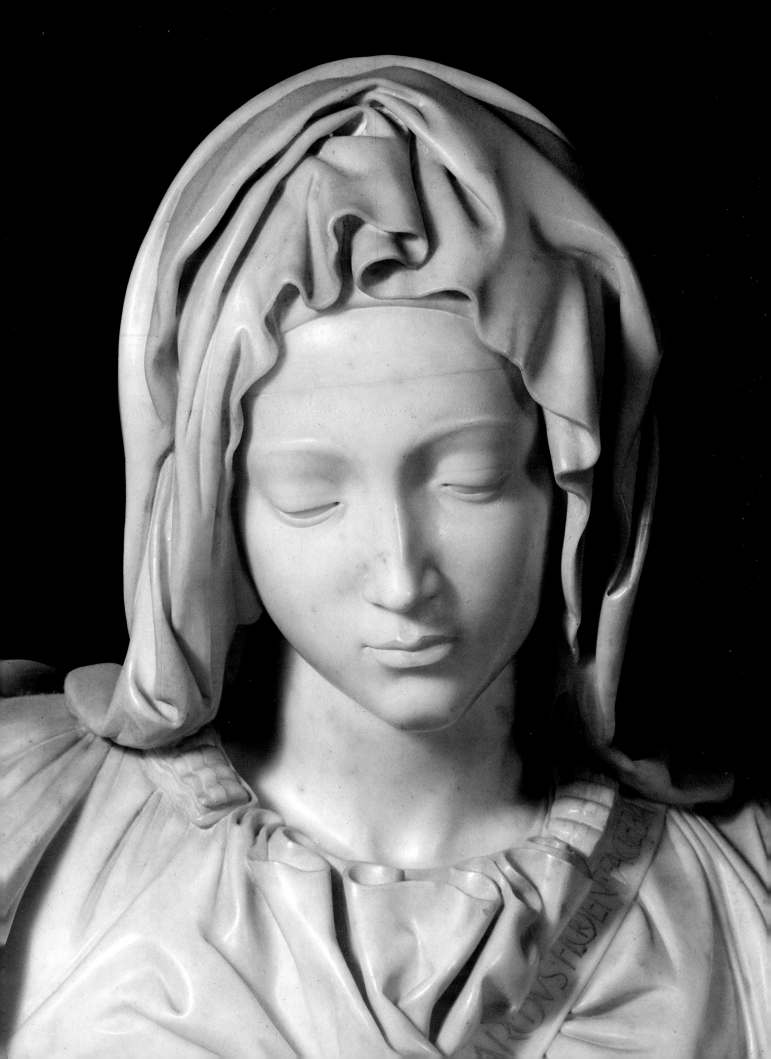

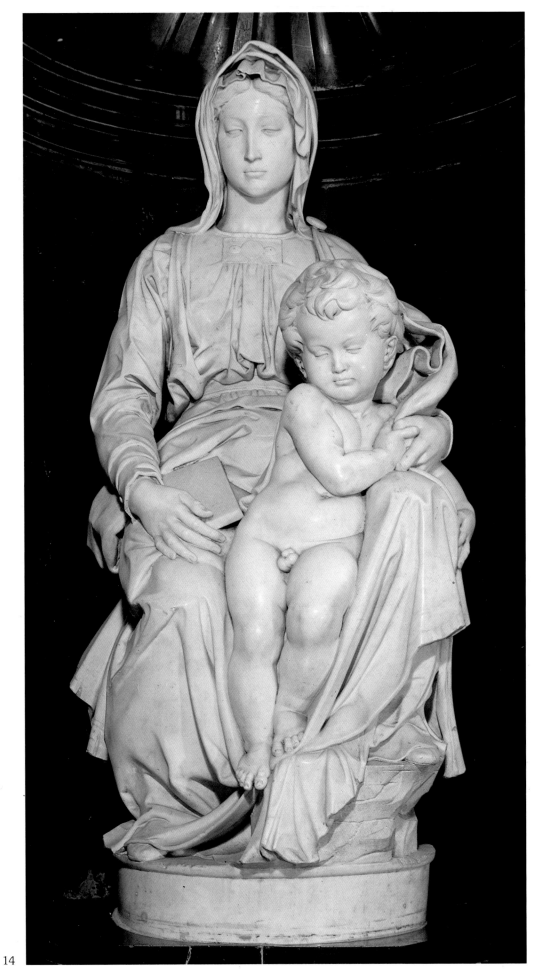

14. *Madonna of Bruges*
h. 128 cms.
Bruges, Notre-Dame

15. *Doni Tondo*
diam. 120 cms.
Florence, Uffizi

14

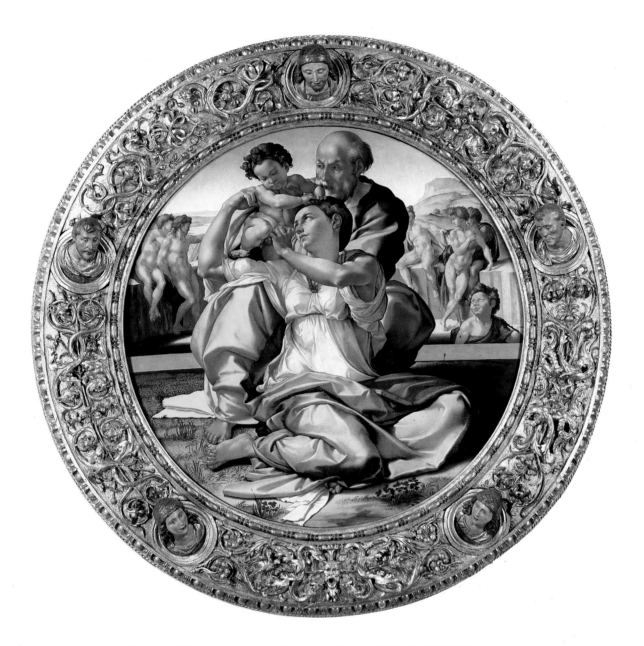

At the service of the Florentine Republic: 1501-1505

On the 4th of August 1501, after many years of political chaos, Florence was declared a Republic, and a friend of Michelangelo's, Piero Soderini, was elected life gonfaloniere, a position of high governmental importance in Florence in those years. It is most likely that Michelangelo was never, in any other period of his life, so unconditionally in agreement with the political order of his native city as in the following four years. This caused him to express his political leanings in his works in such a way as he only rarely did in later years.

20 Twelve days after the Declaration of the Republic, he was commissioned to create the *David* by the Arte della Lana, the very rich Guild of Wool Merchants who were responsible for the upkeep and the decoration of the Cathedral. For this purpose,

he was given a block of marble which Agostino di Duccio had already attempted to fashion forty years previously, perhaps with the same subject in mind. Michelangelo breaks away from the traditional way of representing David. He does not present us with the winner, the giant's head at his feet and the powerful sword in his hand, but portrays the youth in the phase immediately preceding the battle: perhaps he has caught him just in the moment when he has heard that his people are hesitating, and he sees Goliath jeering and mocking them. The artist places him in the most perfect "contraposto", as in the most beautiful Greek representations of heroes. The right-hand side of the statue is smooth and composed, while the left side, from the outstretched foot all the way up to the disheveled hair,

16

17. *Taddei Tondo*
diam. 109 cms.
London, Royal Academy

18. *Pitti Tondo*
Detail of the Virgin
Florence, Museo Nazionale del Bargello

17

18

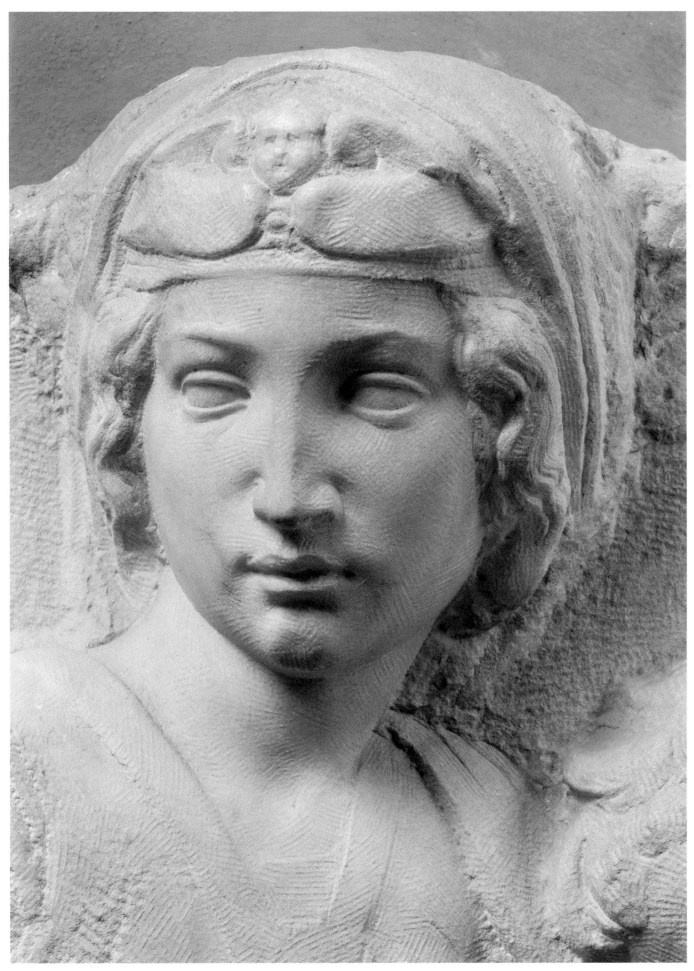

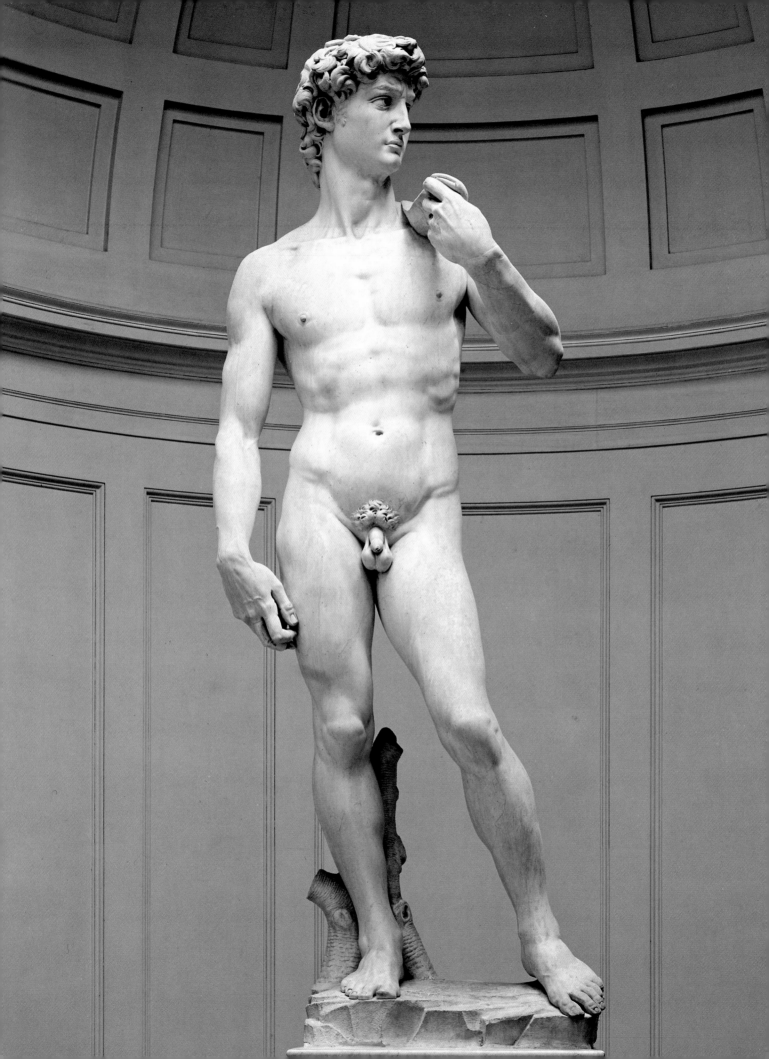

is openly active and dynamic. The muscles and the tendons are developed only to the point where they can still be interpreted as the perfect instrument for a strong will, and not to the point of becoming individual self-governing forms. Once the statue was completed, a committee of the highest ranking citizens and artists decided that it must be placed in the main square of the town, in front of the Palazzo Vecchio, the Town Hall. It was the first time since antiquity that a large statue of a nude was to be exhibited in a public place. This was only allowed thanks to the action of two forces, which by a fortunate chance complemented each other: the force of an artist able to create, for a political community, the symbol of its highest political ideals, and, on the other hand, that of a community which understood the power of this symbol. "Strength" and "Wrath" were the two most important virtues, characteristic of the ancient patron of the city Hercules. Both these qualities, passionate strength and wrath, were embodied in the statue of David.

In 1504, after the completion of the *David*, the Republic commissioned Michelangelo with a new great task: he was to paint on the left wall of the large Council Hall a representation of *The Battle of Cascina*. In 1503 Leonardo had already been commissioned to paint a fresco of *The Battle of Anghiari* on the right wall and Michelangelo could not remain indifferent to the fame and skill of this great artist, 23 years his senior. So he decided at first to follow the example of Leonardo's drawings and to paint the scene of a battle of cavalry. But later he changed his mind and decided to portray the Florentine soldiers as they bathed in the Arno on the eve of battle: according to the story of a contemporary chronicler, it was not until they were warned by a more alert companion that they began to prepare themselves, in the nick of time, for what was to be a victorious battle.

Michelangelo's years in Florence brought him, in addition to these large and important tasks, also
14 a series of private commissions, such as the *Madonna of Bruges* which, originally, may have been created for the Piccolomini Altar of the Cathedral in Siena. The old theme of the Mother and Child is seen here in a new grouping: Mary sits in an absolutely vertical position, peaceful and dignified, and her face shows the serious yet mild characteristics of Leonardo's women. The Child, on the other hand, is presented in a free and loose attitude, leaning against the Madonna's raised knee, almost like an ancient "putto" or little angel. He has got down from his mother's lap, thus acquiring remarkable independence. We no longer have the divine intimacy of Mother and Child: in fact, there is almost a slight contrast between the grave beauty of the

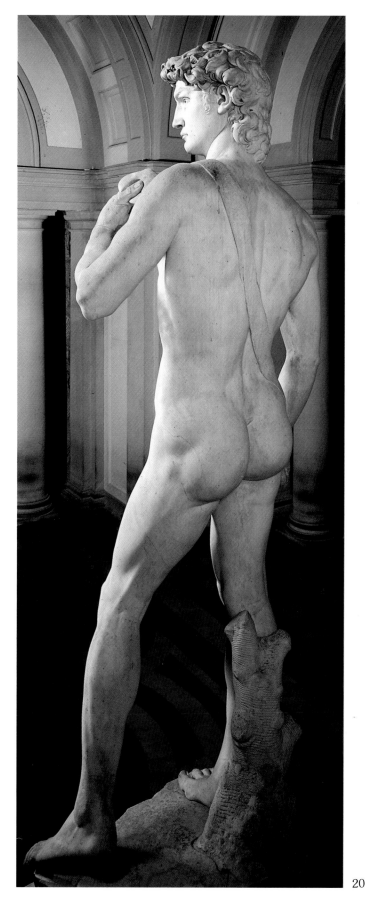

20

19, 20. David
h. 410 cms.
Florence, Galleria dell'Accademia

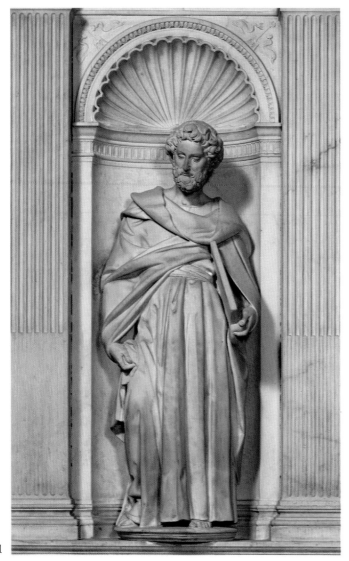

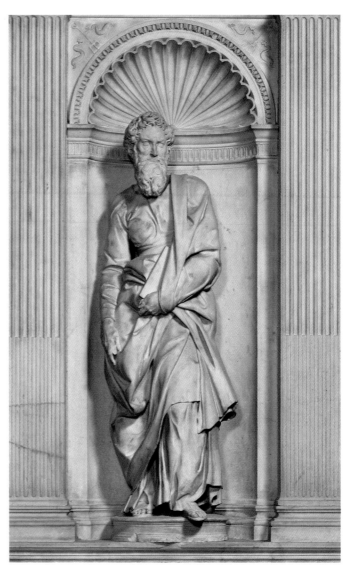

21

22

young woman and the youthful grace and mobility of the divine Child.

16 In the *Tondo Pitti* Michelangelo placed, next to the stern Madonna, a Child whose pose recalls that of ancient funeral genii. Thus the overall effect, despite the apparently playful attitude of the Child, is deeply serious, and the Madonna has an almost prophetic force, because of her size, which bursts out from the frame of the relief.

 If one looks at the series of works so far discussed and understands the development of the artist, it 15 becomes impossible to think of the *Tondo Doni* as the "exercise of a carpenter," as one critic proclaimed. Mary is on her knees in front of the richly clothed legs of St. Joseph and holds out to him, upon her right shoulder, the Child, whom Joseph has already grasped by the left hand. The way the Madonna looks up at the Child is both loving and worshipping. St. Joseph, who, in the works of other artists, is often an embarassed, secondary figure, here crowns the group with his powerful head. Could it perhaps be acceptable to interpret this Joseph as God the Father, the real Father of Jesus Christ and the one to Whom he must return?

 Of all Michelangelo's representations of the Madonna, the *Tondo Taddei* is perhaps the most 17 dynamic of them all. The Child, according to the model of an ancient sarcophagus representing a son of Medea in flight, is presented in an attitude of frightened escape when faced with a flapping bird which the childish St. John is showing him. This model blending of classical antiquity and nature, totally in agreement with the aesthetic theories of the time, gives this relief a grace in rendering the instantaneous event which is unusual for the artist.

 The last commission which Michelangelo received during these happy four years spent in Florence, was a collection of the twelve Apostles for the niches of the Choir of the Cathedral, which he began in 1503. Although we have the drawing for another statue, *St. Matthew* was the only one 23 he managed to complete before the contract was annulled when he moved to Rome.

22

21. Saint Paul
h. 127 cms.
Siena, Cathedral

22. Saint Peter
h. 124 cms.
Siena, Cathedral

23. Saint Matthew
h. 271 cms.
Florence, Galleria
dell'Accademia

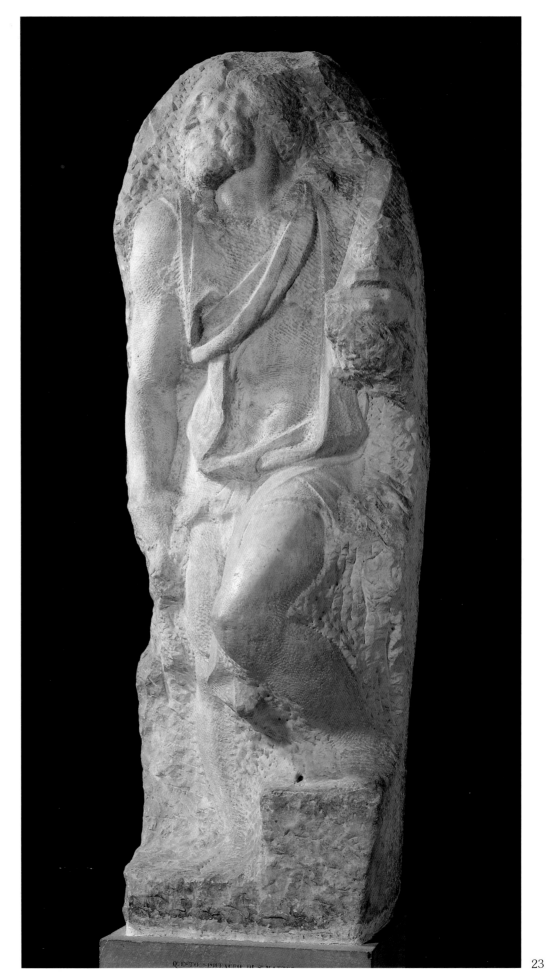

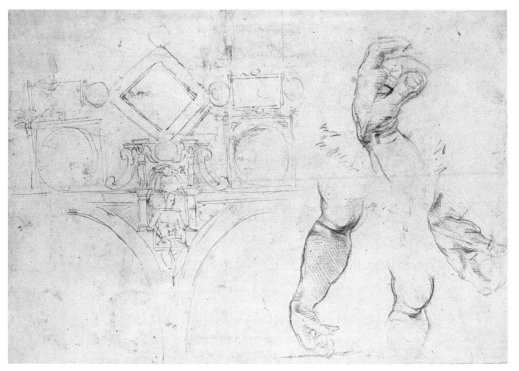

24. Study for the Sistine Ceiling London, British Museum

25. Sistine Chapel Vatican

Michelangelo and Pope Julius II: 1505-1513

When, by the will of Pope Julius della Rovere (1503-1513), Michelangelo went to Rome in March 1505, he realized, in the course of a year, how different in every way the atmosphere of the papal court was from that of his own native city. The Pope received him with a truly imperial commission: to build in the course of five years and for the sum of 10,000 ducats, a tomb for the Pope. Forty life-sized statues were to surround the tomb, which was to be 23 feet wide, 36 feet 3 inches deep and 26 feet 4 inches high; it was to be a free-standing tomb and to contain an oval funerary cell. Never, since classical times, had anything like this, in the West, been built for one man alone.

According to the iconographic plan, which we are able to reconstruct from written sources, this was to be an outline of the Christian world: the lower level was dedicated to man, the middle level to the prophets and saints graced with Divine Bliss, and the top level to the surpassing of both former levels in the Last Judgment. Only if we remember this can we understand the "Victories" and the "Slaves" intended for the lower level: the former were female figures with nude men in chains at their feet, the latter were nude men in chains. These are none other than the representations of virtues and the Liberal Arts, but, unlike the customary sixteenth-century portrayals, they are not presented as pure personifications of the highest ideals, but in the form

in which men on earth experience them: without freedom and continually struggling against the powers opposing them. *Moses* and St. Paul (never executed) among others, were to have been placed in the middle level, surrounded by representations of examples of the active and contemplative lives. At the summit of the monument, following Giovanni Pisano's example of the tomb of an empress built 200 years previously, there was to have been a portrayal of two angels leading the Pope out of his tomb on the day of the Last Judgment.

Michelangelo immediately began his preparations for this task, but now he was to discover the imperious and capricious character of his patron: the Pope, in doubt of finding an appropriate place in which to erect his tomb, planned something even more grandiose: the restoration and remodelling of St. Peter's. While his mind was occupied with these new projects, he temporarily postponed the execution of the previous ones. Michelangelo tried in vain to obtain a Papal audience, until he was finally thrown out of the palace by a soldier; and on the 17th of April, the day before the first stone of St. Peter's was to be laid, he fled from Rome and, in distress, made his way towards Florence. Fear and bitterness filled his heart during the following two years, while, by order of Julius II, he had to stay in Bologna to complete a most unsatisfying commission. In 1508 he returned to Rome

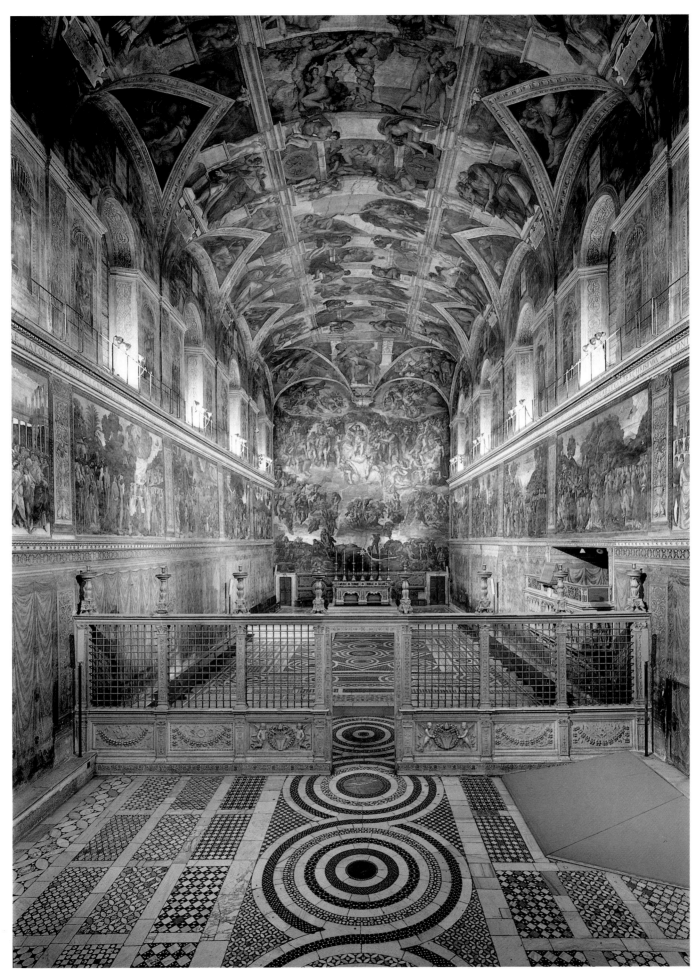

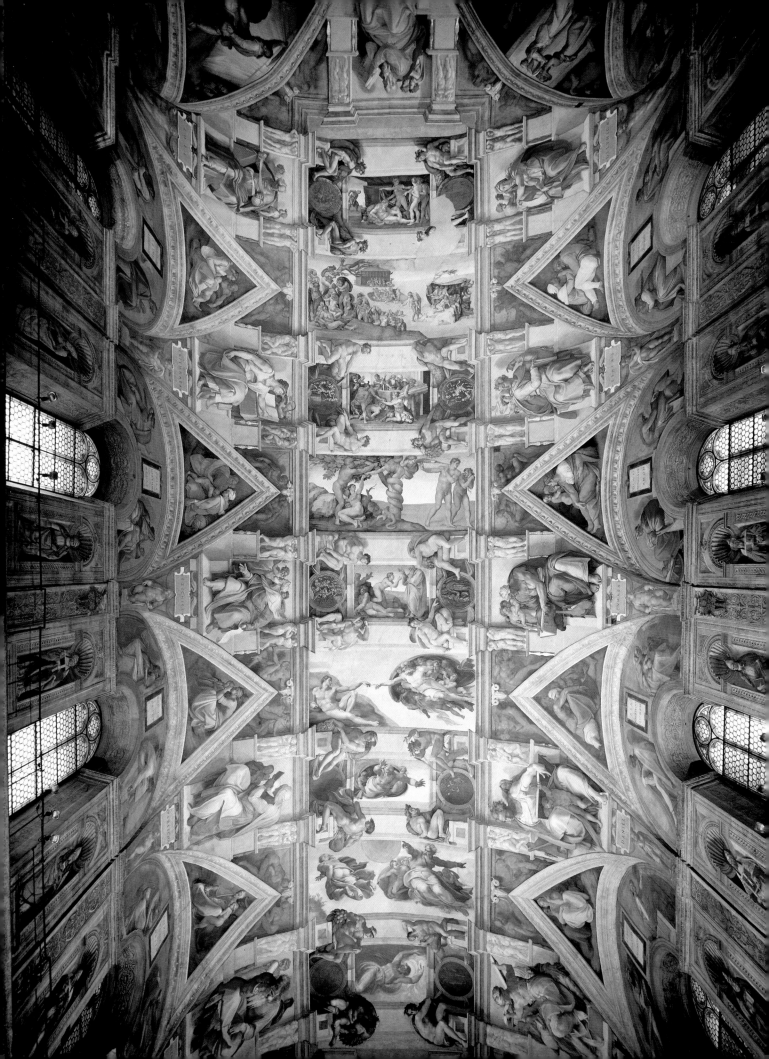

without, however, being allowed to begin work on the tomb. Another bewildering task was waiting for him. He was to paint the Twelve Apostles and a few ornaments on the ceiling of the Sistine Chapel. He, who had always insisted that he was a sculptor, was thus to learn the art of fresco painting, and practise it on a vault decorated by fifteenth-century artists as a starry sky. However, as he began work on the project the affinity between the Pope and the artist made itself felt as in those earlier weeks when the tomb had first been planned. Julius II allowed himself to be carried away by Michelangelo's creative violence and the two inspired each other in turn with always grander designs for the decoration of the ceiling of the chapel; and the artist's imagination, years earlier stimulated at the idea of constructing the tomb, was finally, even though in a different artistic genre, given free rein. Michelangelo spent the time between then and the 31st of October 1512 painting more than 300 figures on the ceiling of the Sistine Chapel.

Between the lunettes and spandrels depicting Christ's ancestors are the *Prophets* and *Sybils*, who 27-30 appear to be much larger than they really are. The violence and the power of these figures, however, is not due to their superhuman size, but mostly to

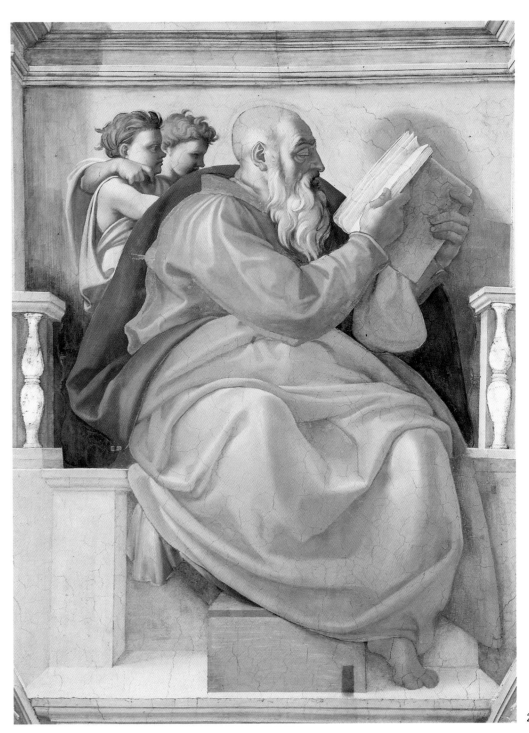

26. *Ceiling of the Sistine Chapel Vatican*

27. *Sistine Chapel The Prophet Zachariah Vatican*

27

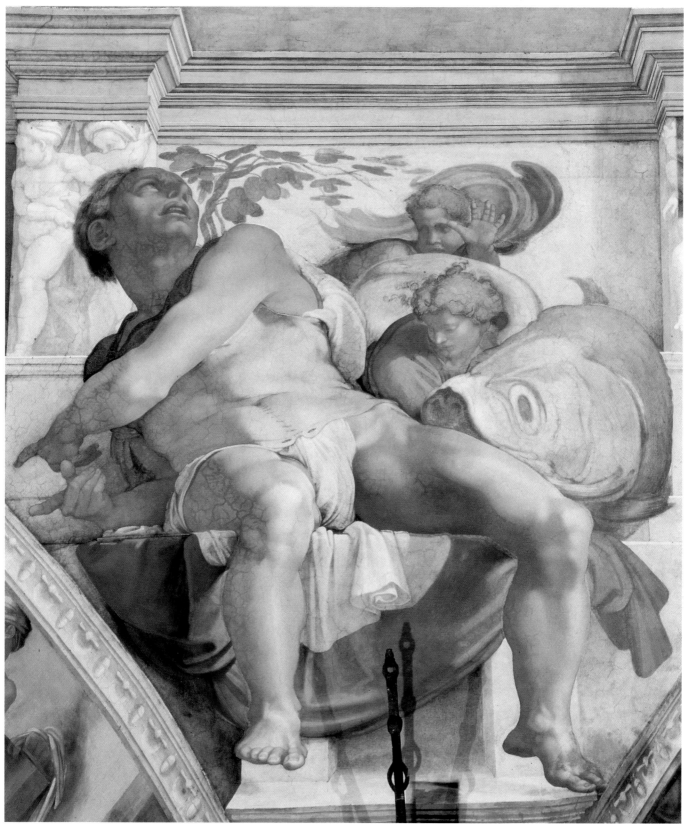

28. *Sistine Chapel*
The Prophet Jonah
Vatican

29. *Sistine Chapel*
The Lybian Sibyl
Vatican

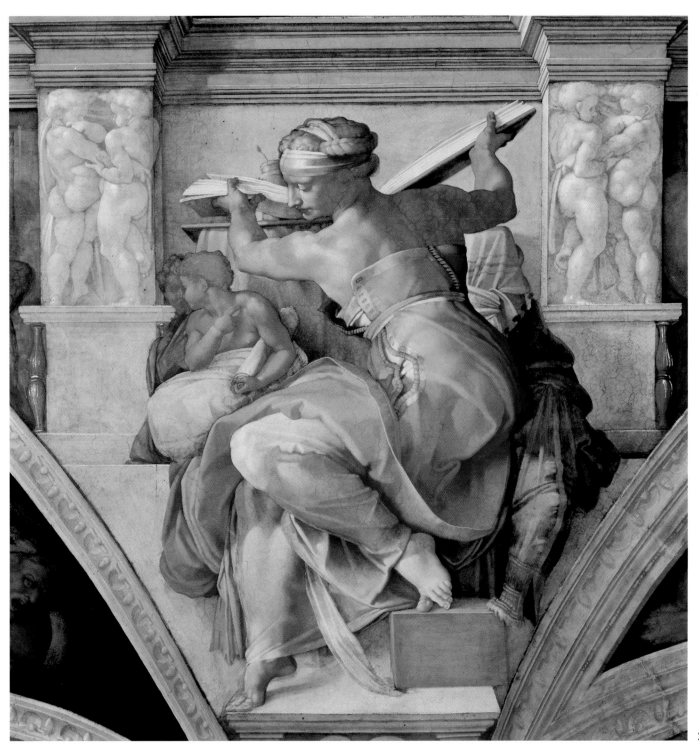

their isolation. Each of these figures, in its own way, seems totally enraptured in the spiritual act of contemplation, intuition and ecstasy; they seem the personification of that divine spirit which briefly at times uses them as agents in communicating to other men.

The artist began painting his scenes from the east side of the Chapel and in reverse order of the Bible. The second painting, which, together with the *Sacrifice and Derision of Noah,* belongs to the first phase of the work (before September 1509), 35 represents the *Flood.* Michelangelo has caught the

decisive moment in this painting: the last rising of the waters which drives men to the most desperate and extreme efforts. Every detail is dramatic in a simple yet highly effective way. Nevertheless, the themes of love and sacrifice are greatly superior to those of selfishness and of instinctive self-preservation. These human beings seem to yield amidst suffering and pain to a natural catastrophe, rather than to feel threatened and crushed by a punishment for their own evil.

Michelangelo's *Paradise* is not a dazzling garden. 36 Adam and Eve are alone and nothing earthly can

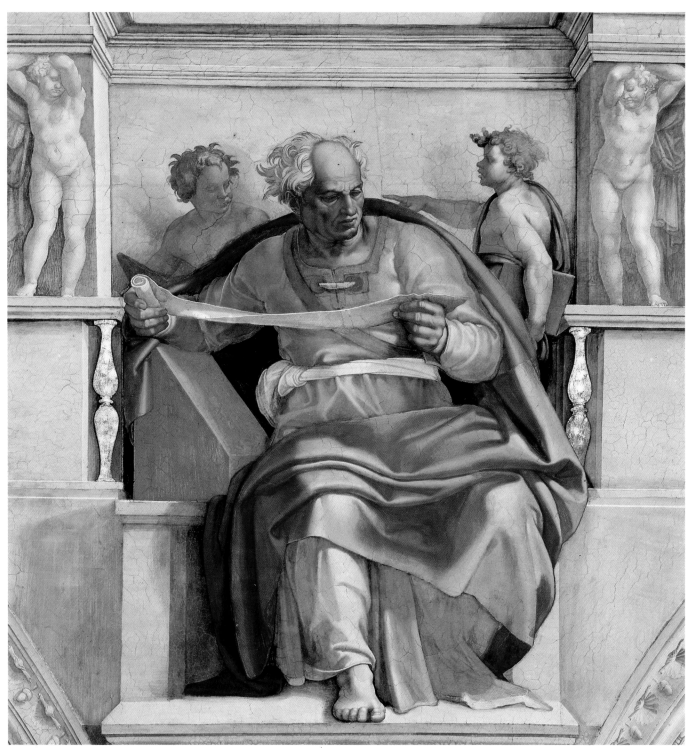

30. Sistine Chapel
The Prophet Joel
Vatican

31. Sistine Chapel
The Creation of Adam, detail
Vatican

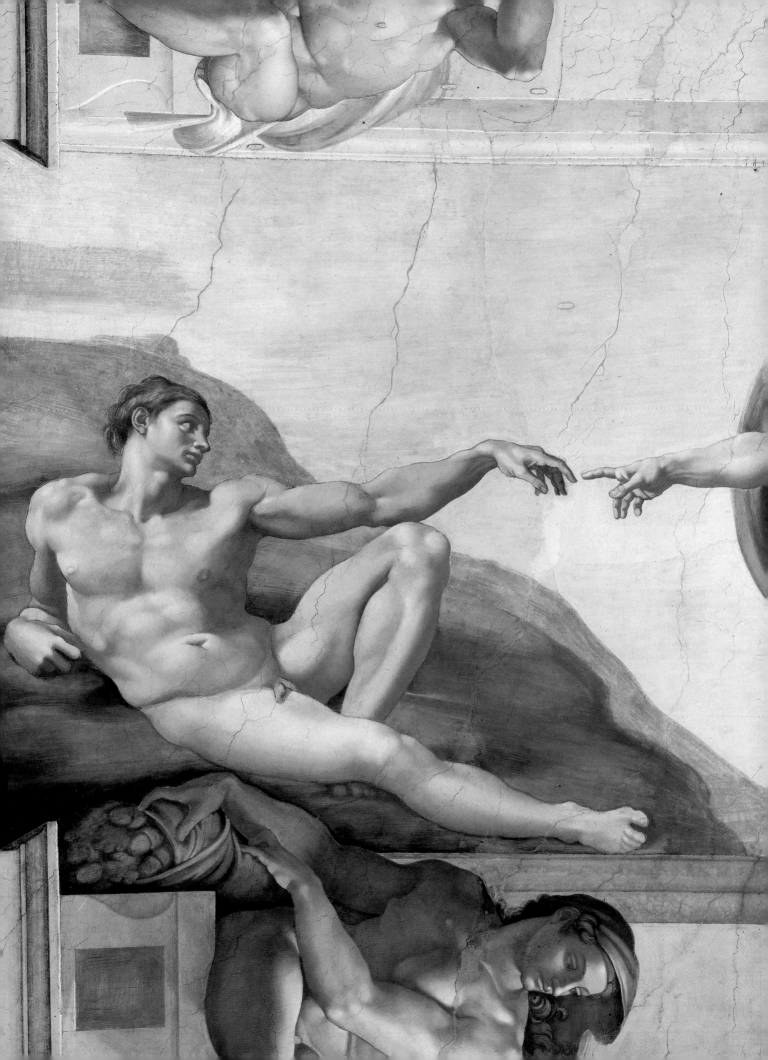

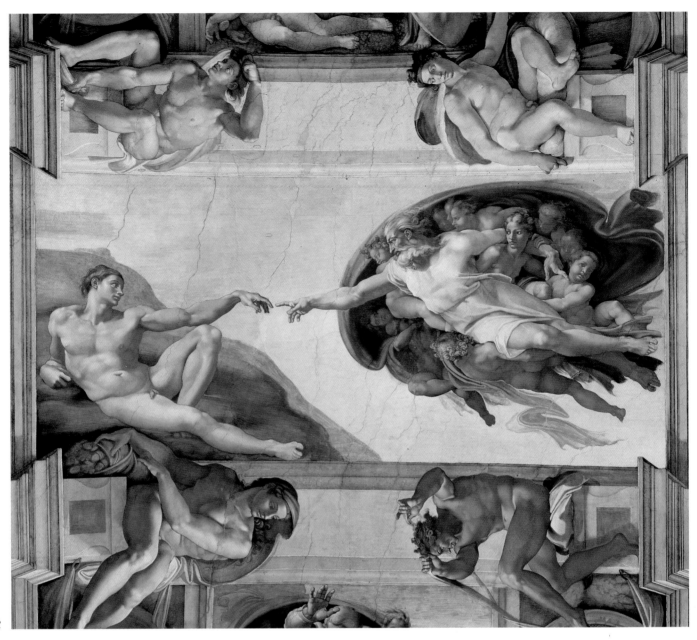

32

attract their attention. Only the Tree of Knowledge worries them, asking them to make a decision, which they are compelled to take together. The woman is no longer the guilty party, but both are guilty to the same extent and are moulded together in an insoluble unity, unable to resist the desire for knowledge.

As he goes on the artist limits himself more and more to fewer and larger figures. The means of representation become more elementary as the events go further back towards the origins of the world. The figure of God in the *Creation of Eve* occupies almost a third of this painting. All its power is gathered into His expression and into His raised hand ordering the woman to rise up from the man's side. In the *Creation of Adam,* God and man appear almost as equals. Adam lies on raised rocks and, lifting himself up slightly, without any show

34

32

32. Sistine Chapel
The Creation of Adam
Vatican

33. Sistine Chapel
The Creation of the Heavens, detail
Vatican

34. Sistine Chapel
The Creation of Eve
Vatican

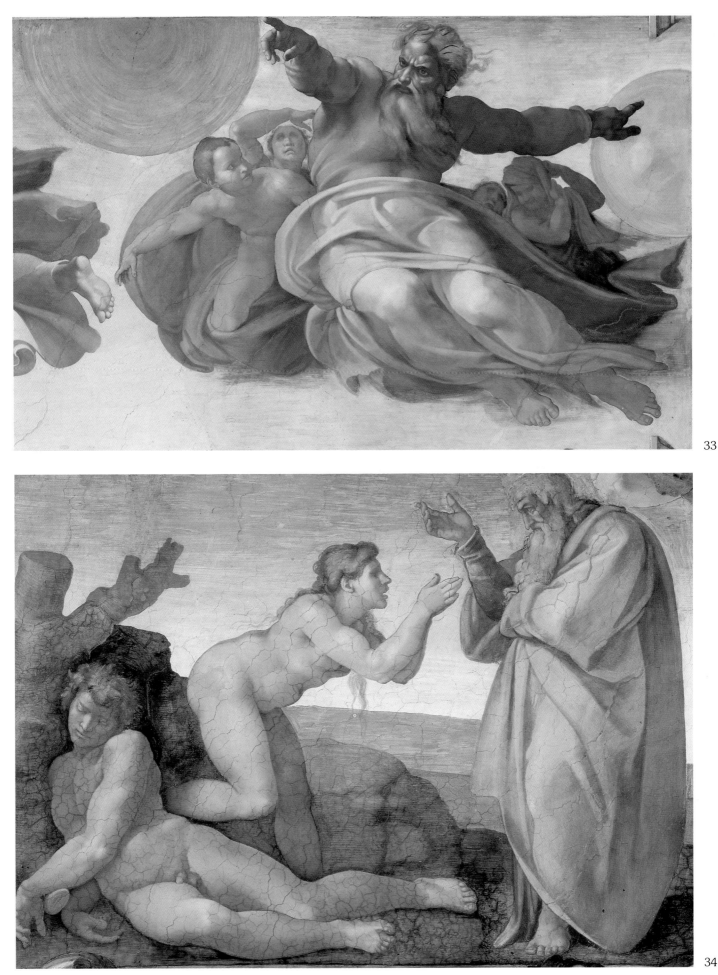

33

34

33

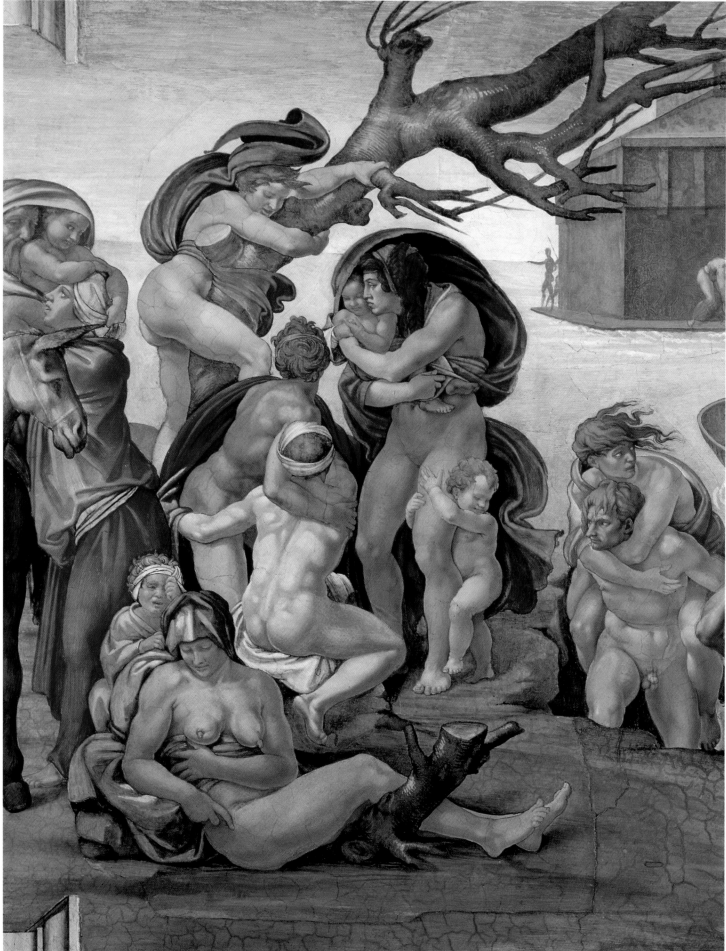

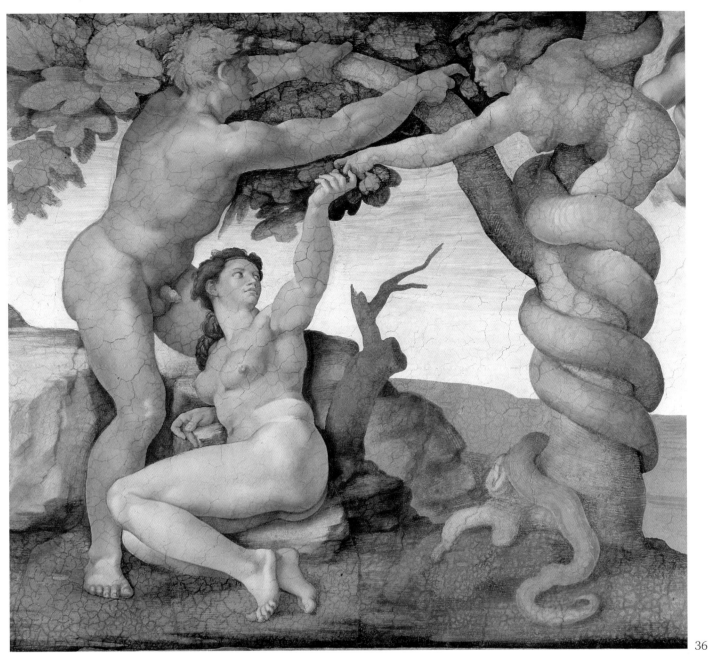

35. Sistine Chapel
The Flood
Vatican

36. Sistine Chapel
The Fall
Vatican

37. Sistine Chapel
Jesse-David-Solomon
lunette
Vatican

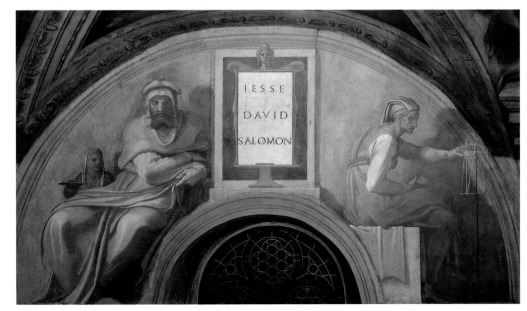

36

37

31 of effort he stretches out his arm towards God. He arrives floating in space, His powerful cloak flying about Him, accompanied by angels. When His pure, strong gaze meets the man's longing look, the spark of divinity passes from the pointed finger of His right hand to Adam. Michelangelo does not show us the event of man's creation, but the moment in which man receives his soul, the reward for his desire for divinity. At the right-hand side of the penultimate large scene, reproduced here, the

33 *Creation of the Heavens,* a stormy image of God appears from the depths of space and with a powerful, creative gesture shows the way to the celestial bodies. There was only one more instance to paint: God creating earthly matter and light. One feels that the artist put into this scene all that was known in his time of the ancient myths and the philosophies concerning the creation of the world. With raised arms and spinning with a whirlwind effect, God, the pure spirit, the pure form, unites with primaeval matter to generate the first element.

Soon after the completion of the ceiling of the Sistine Chapel, in 1513, Pope Julius II died. In this same year Michelangelo and the Pope's heirs reached a new agreement concerning the tomb. It was decided that the tomb was to be smaller and placed against a wall. From a copy by Iacopo Rocchetti of a badly preserved drawing of Michelangelo's, we can see what the monument was to have looked like. Michelangelo began work at

44 once on *Moses* and two of the "Slaves". His Moses has always been seen as an idealized portrait both of the Pope and of the artist. In fact one must interpret the combination of dignified passion for good and a simple yet powerful strength as the utmost ideal both of the Pope and the artist.

38 The strong vitality and beauty of the *Dying*
39 *Slave* and the *Rebelling Slave* are certainly enough to lift these statues far above the mark of pure bodily strength and its baseness. The road which Michelangelo had covered from the time when he was allowed to begin had been difficult and painful. Now he had at hand his personal experience for the representation of the Liberal Arts, figures in chains, which he shows us in their earthly semblance, almost like man fighting against destiny.

When Giovanni de' Medici, who had lived in the same house as Michelangelo from 1489 to 1492, was elected Pope in 1513, he too, as his predecessor, decided to take advantage of the artist's talent. In 1516, Michelangelo was so busy working for his new patron that he was forced to sign a new contract with Julius II's heirs for an even smaller tomb. The monument was thus reduced to the depth of a tabernacle, and single female figures were planned to replace the groups of Virtues and Vices. The façade of the lower level, meanwhile completed, was to stay as it was and it is greatly similar to the one finally set up in San Pietro in Vincoli; the upper level, on the other hand, was totally changed apparently as a result of what Michelangelo had learned while making the plans for the Church of 46 San Lorenzo in Florence, which he had been working at since 1515. The construction acquired a new and powerful size: instead of a regular development, characteristic of the fifteenth century, we now have a contraposition of weights and supports, of lower and upper level. The tendency to annul static laws is a symptom of the imminent period of Mannerism, but complete monumentalization is a characteristic of Baroque.

According to his contract, the artist was now allowed to work on the tomb wherever he was. So it is probable that in 1519, in his Florentine studio, he was working at the four so-called "Boboli 40-43 *Slaves,*" which were to have been placed on the columns of the lower level, in the following order: *Atlas, The Young Slave, The Bearded Slave,* and *The Awakening Slave.* The statues are for the most part unfinished, because the Medici never allowed Michelangelo much time to work on things which had not been commissioned by them. Although these were not completed, each one of them shows once more, as the Louvre *Slaves,* how the artist 38, 39 had wanted to create symbols of man's struggle and his suffering.

In 1525 another plan was designed for the tomb of Julius II and, in 1532, yet another; and each time the size was reduced. It was now to be a simple mural tomb; *Moses* and the two Louvre *Slaves* were to be placed on the lower level, and a Madonna, a prophet and a Sibyl on the upper level. The Boboli *Slaves* were thus cancelled from the plan. It is possible that the statue of *Victory* was begun 69, 70 as early as 1519, but whether it was originally planned as part of the tomb is still uncertain. The strong manneristic features (exaggerated contortions and complex movements) link this figure more with the Boboli *Slaves* than with the later Roman sculptures.

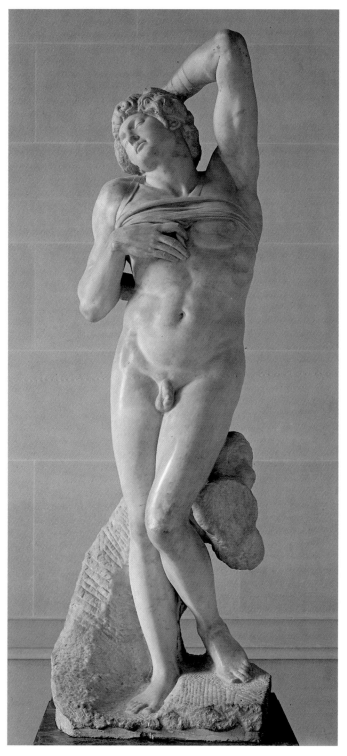

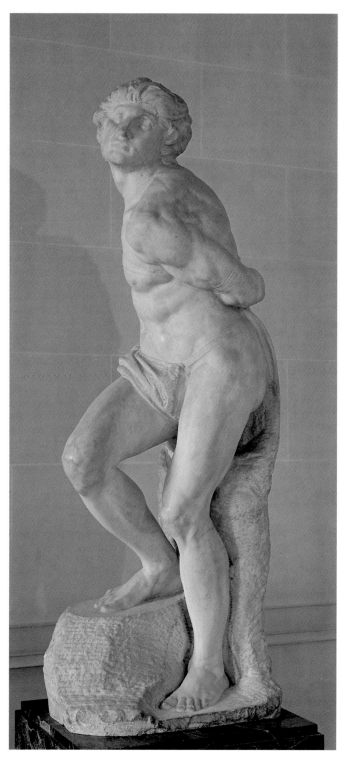

38

39

38. Dying Slave
h. 229 cms.
Paris, Louvre

39. Rebelling Slave
h. 215 cms.
Paris, Louvre

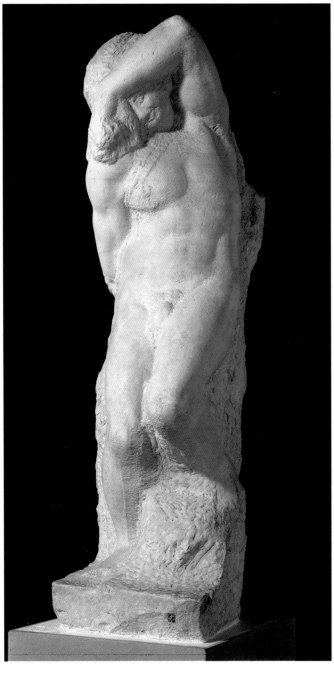

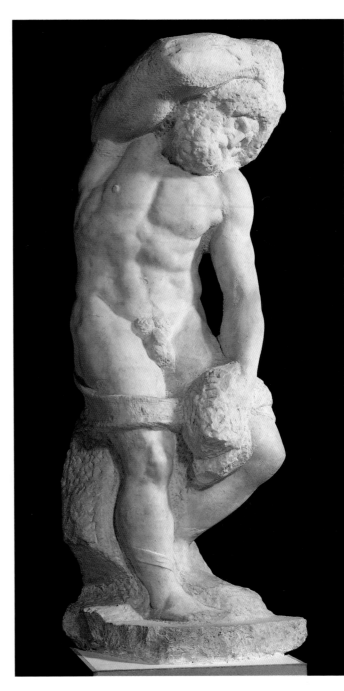

40

41

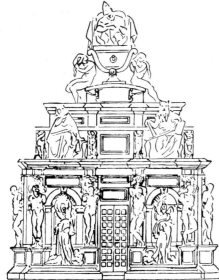

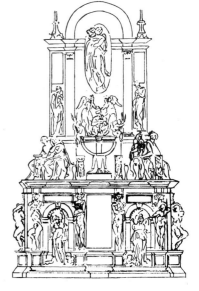

40. Young Slave
h. 256 cms.
Florence, Galleria dell'Accademia

41. Bearded Slave
h. 263 cms.
Florence, Galleria dell'Accademia

◁

Reconstruction of the first
project (1505) for the tomb of
Julius II

▷

Reconstruction of the second
project (1513) for the tomb of
Julius II

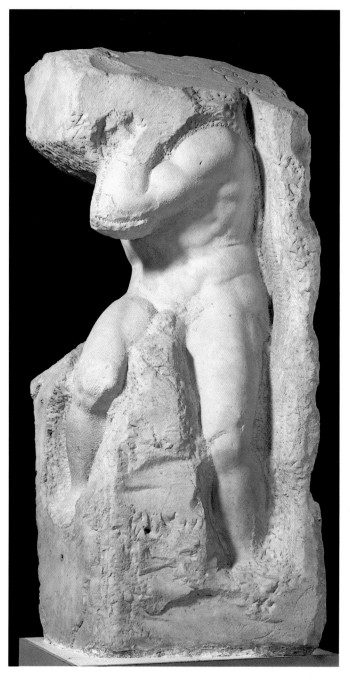

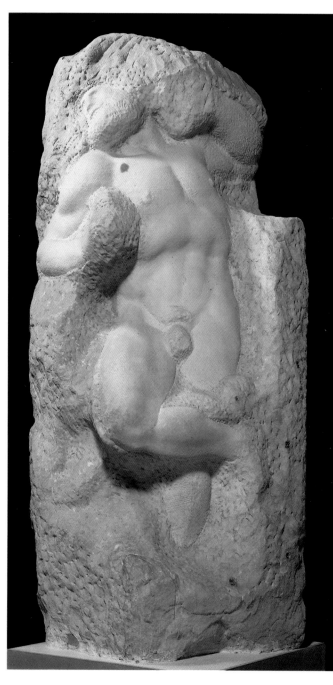

42

43

42. Atlas Slave
h. 277 cms.
Florence, Galleria dell'Accademia

43. Awakening Slave
h. 267 cms.
Florence, Galleria dell'Accademia

◁
Reconstruction of the third
project (1516) for the tomb of
Julius II

▷
Reconstruction of the fifth
project (1532) for the tomb of
Julius II

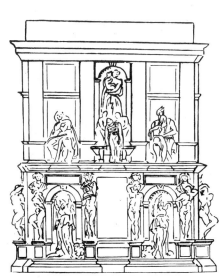

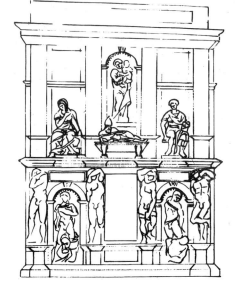

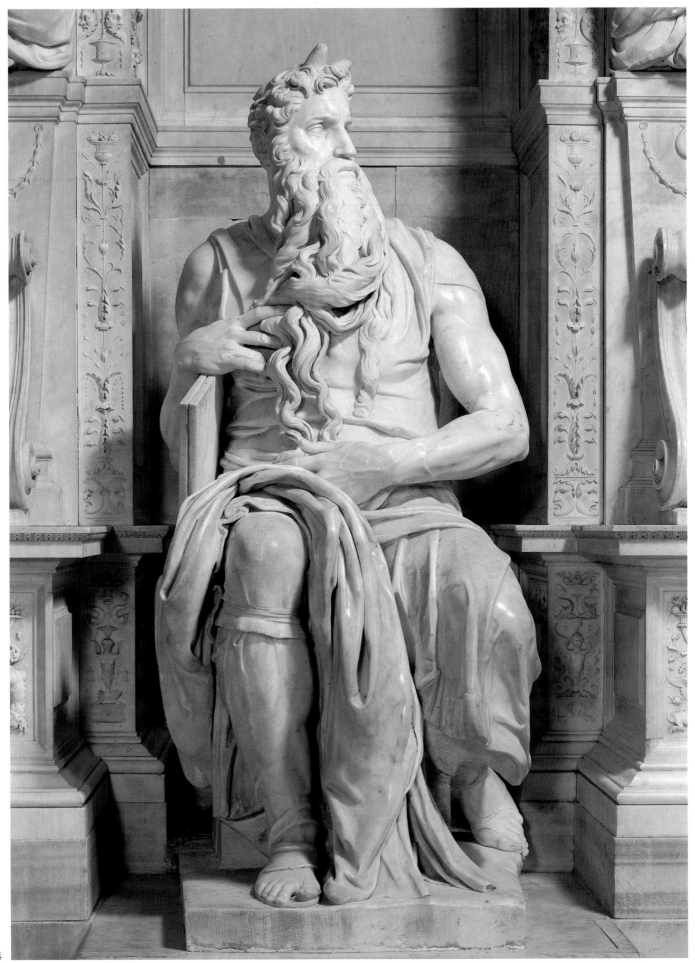

44

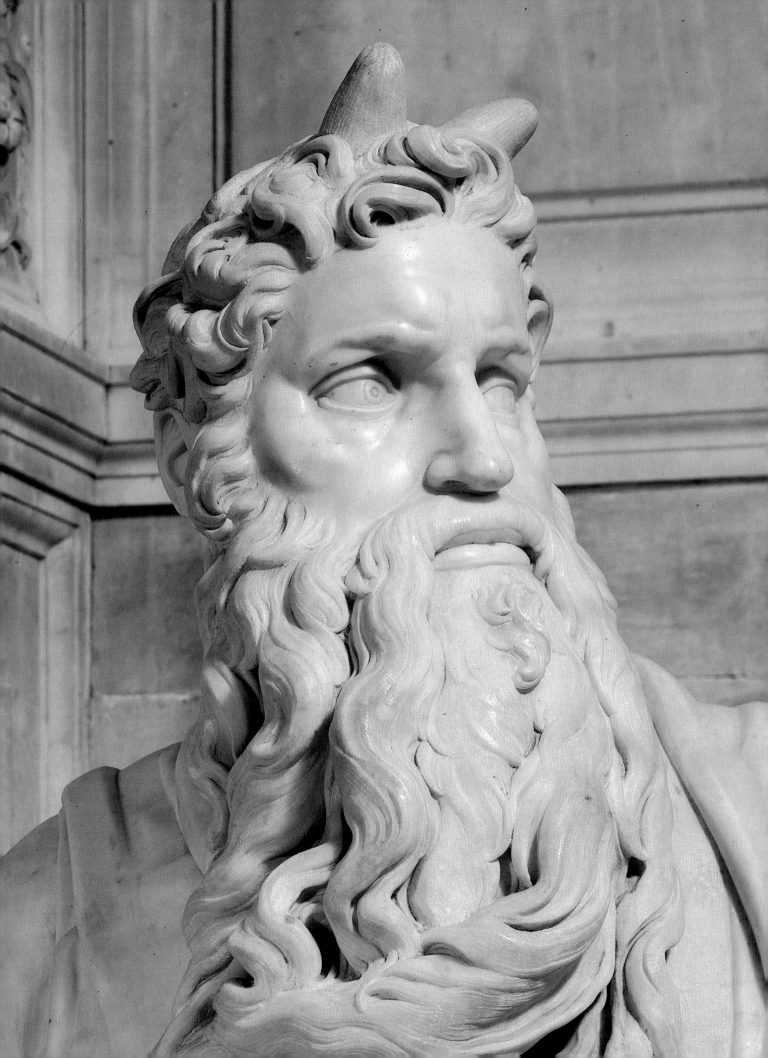

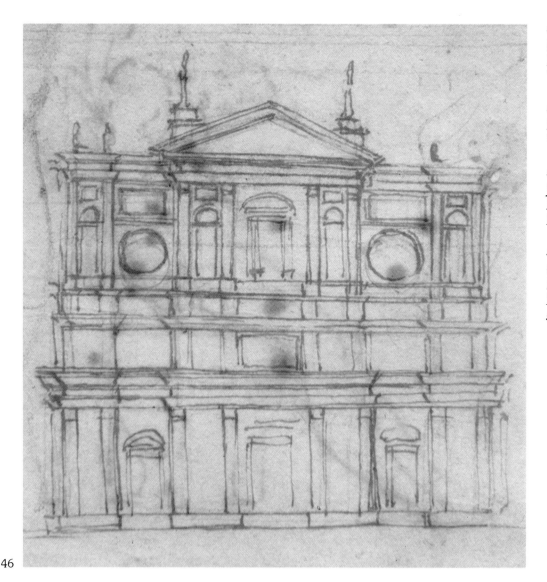

44. Moses
h. 235 cms.
Rome, San Pietro in
Vincoli

45. Moses, detail
Rome, San Pietro in
Vincoli

46. Project for the
façade of San Lorenzo
Florence, Casa
Buonarroti

47. Christ Carrying the
Cross, detail
h. 205 cms.
Rome, Santa Maria
sopra Minerva

At the service of the Medici Popes: 1513-1534

Even during the pontificate of the Medici Pope Leo X (1513-1523), political developments gave Michelangelo no peace. To begin with, the Pope, whose family were enemies of the Della Rovere, prevented the artist from continuing the work on the tomb of Julius II. The design and the execution of the façade of *San Lorenzo* kept him more or less occupied from 1515 onwards. In 1520, after useless wars, the Pope was forced to renounce the façade and charged Michelangelo with the task of building the *Medici Chapel* next to San Lorenzo and, in 1524, the *Laurentian Library*. But these plans too were interrupted for many years, after the Medici were driven out of Florence in 1526. For the last time, Florence was once again declared a Republic and Michelangelo, in the position of Governor of the Fortifications, set to work study-

ing new plans of defense. However, treacherous political schemes aided the return of the Medici and his plans could never be put into effect.

When, in 1520 and 1521, Michelangelo received the commission for the Medici Chapel, this task might have held strictly personal interest for him. For Leo X wanted to combine the tombs of his younger brother Giuliano, Duke of Nemours, and his nephew Lorenzo, Duke of Urbino, with those of the "Magnifici", Lorenzo and his brother Giuliano, who had been murdered in 1478; their tombs were then in the Old Sacristy of San Lorenzo, built by Brunelleschi and decorated by Donatello. In his youth, Michelangelo had been their friend, and Lorenzo Il Magnifico had been his most important patron.

But the renunciaton of the façade was so great

46

66-68

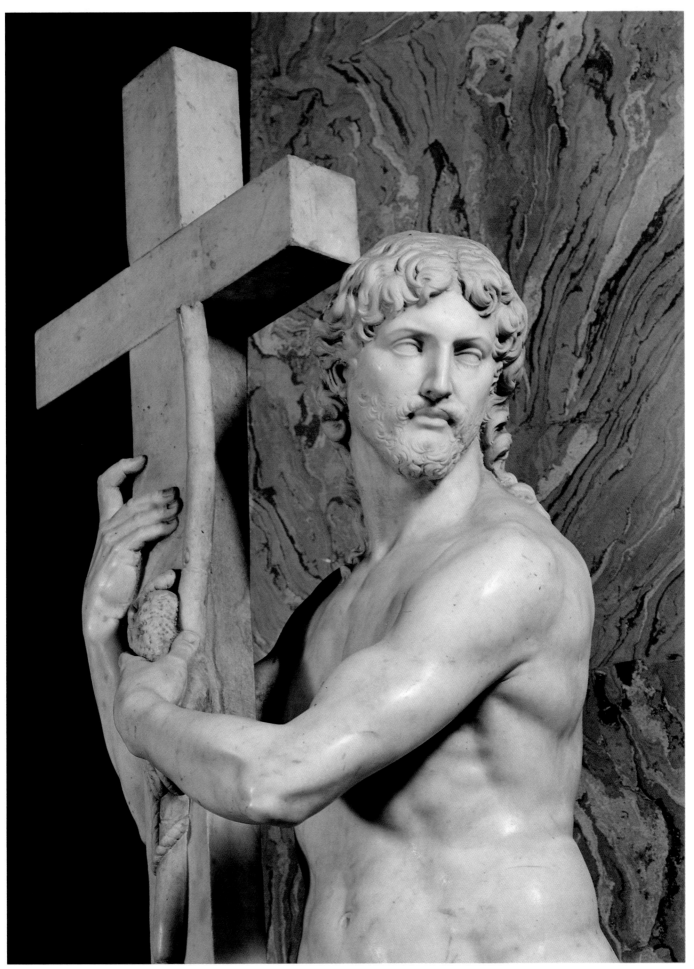

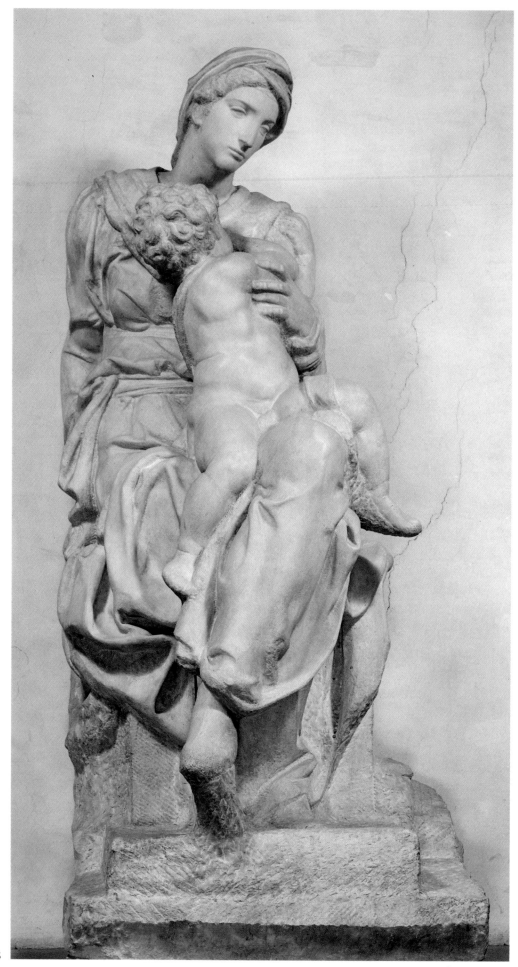

48. Madonna and
Child
h. 226 cms.
Florence, New Sacristy
of San Lorenzo

49. Madonna and
Child, detail
Florence, New Sacristy of
San Lorenzo

50. Tomb of Lorenzo
de' Medici
Florence, New Sacristy
of San Lorenzo

51. Tomb of Lorenzo
de' Medici
Detail of Lorenzo
Florence, New Sacristy
of San Lorenzo

52. Tomb of
Lorenzo de' Medici
Detail of Twilight
Florence, New Sacristy
of San Lorenzo

53. Tomb of Lorenzo
de' Medici
Detail of Dawn
Florence, New Sacristy
of San Lorenzo

48

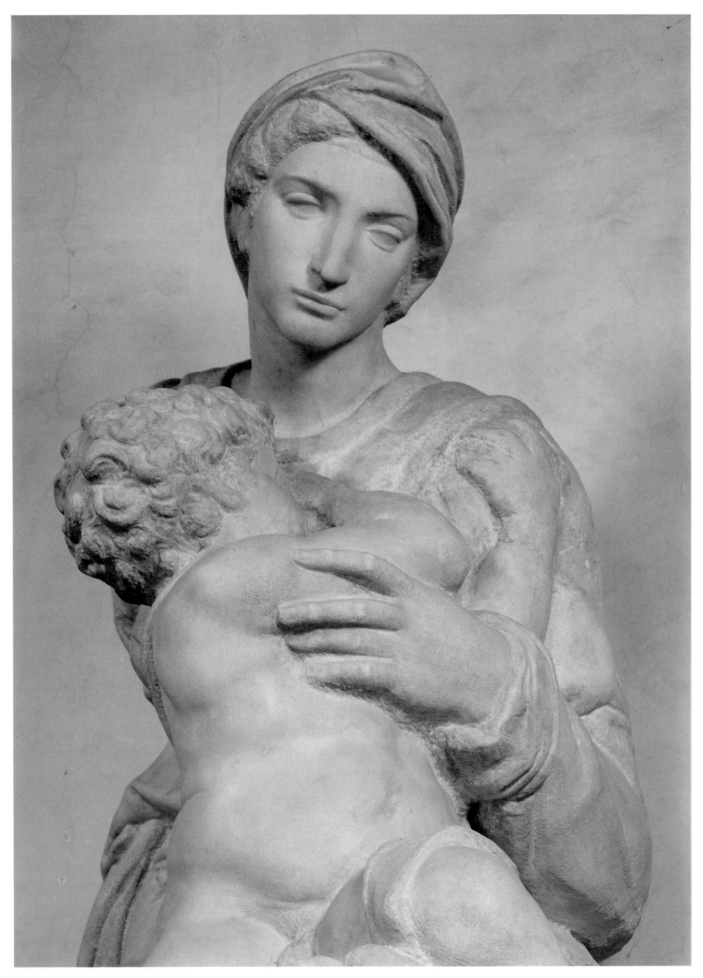

49

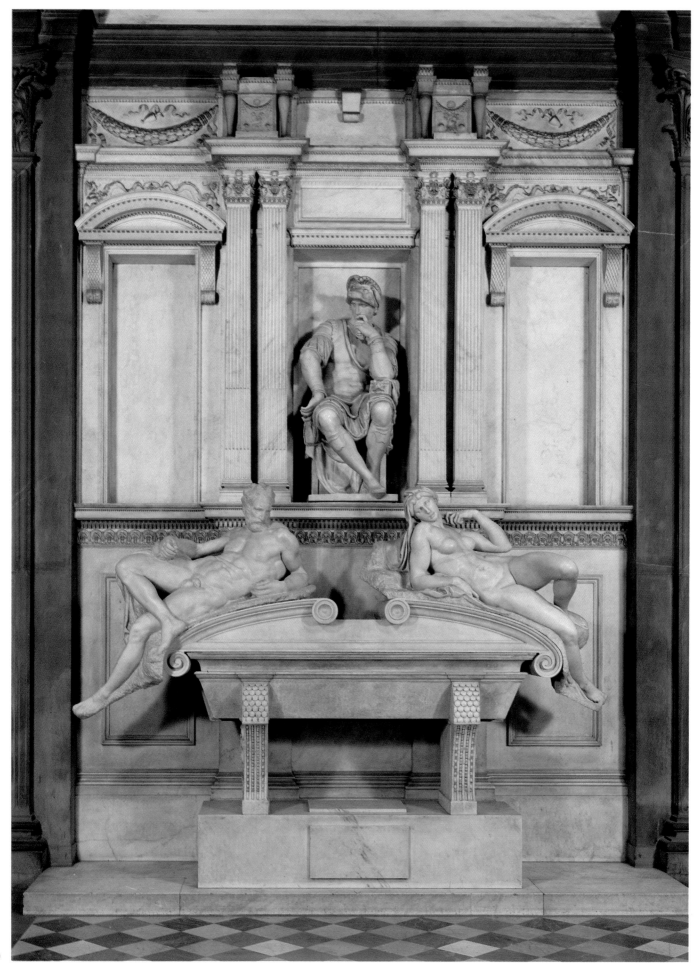

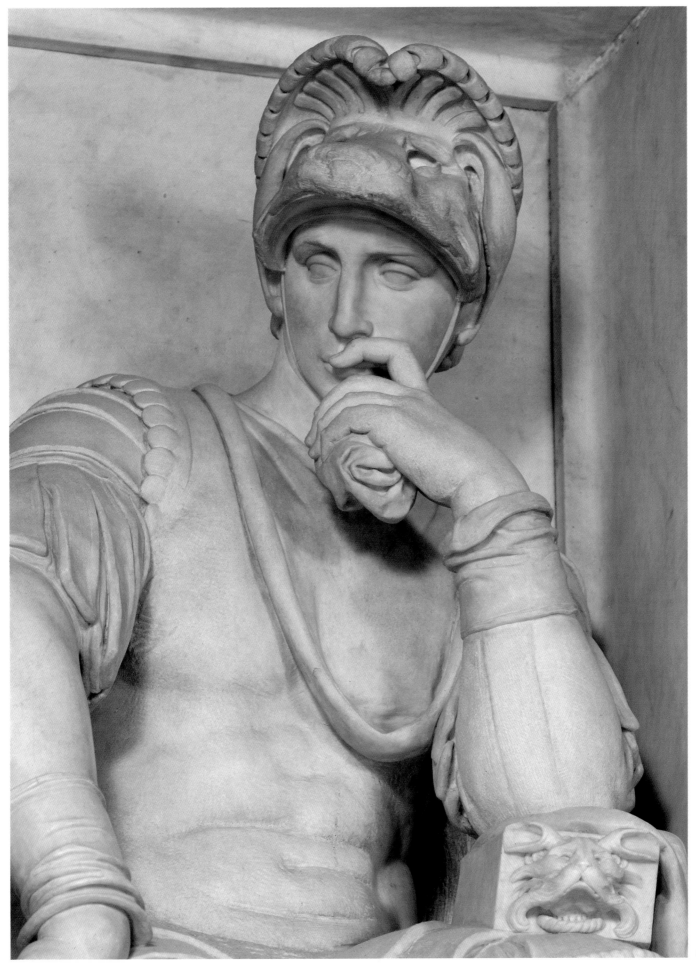

51

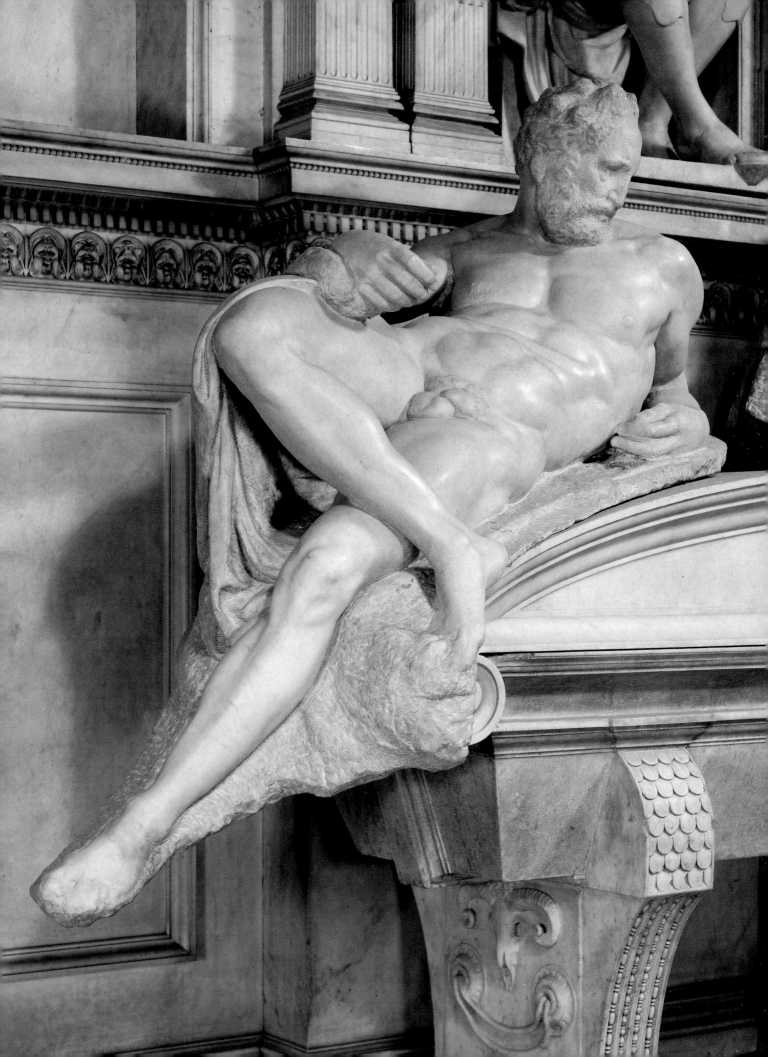

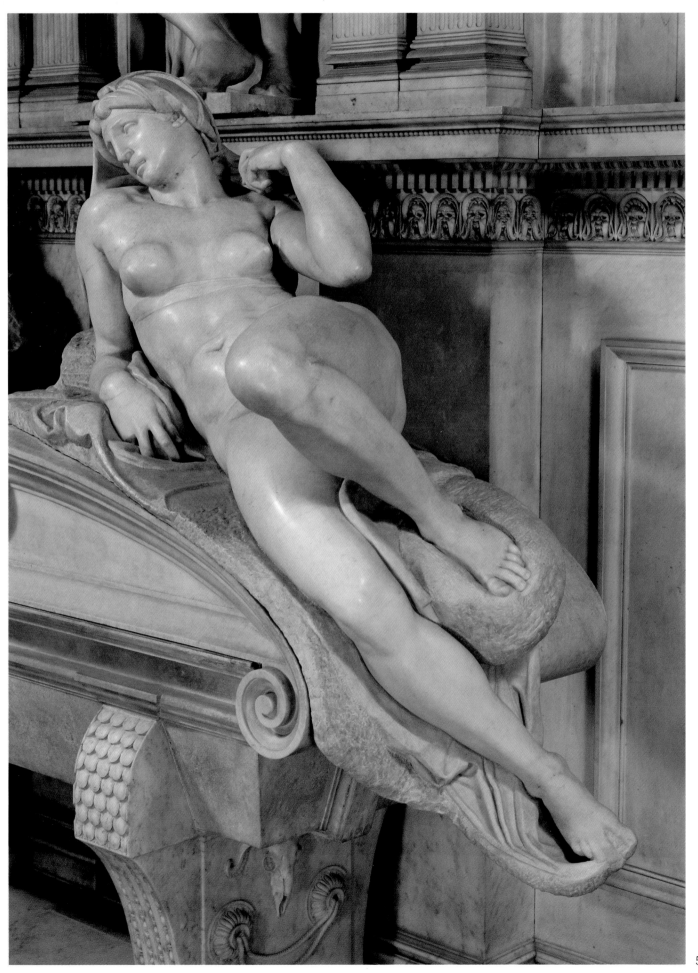

53

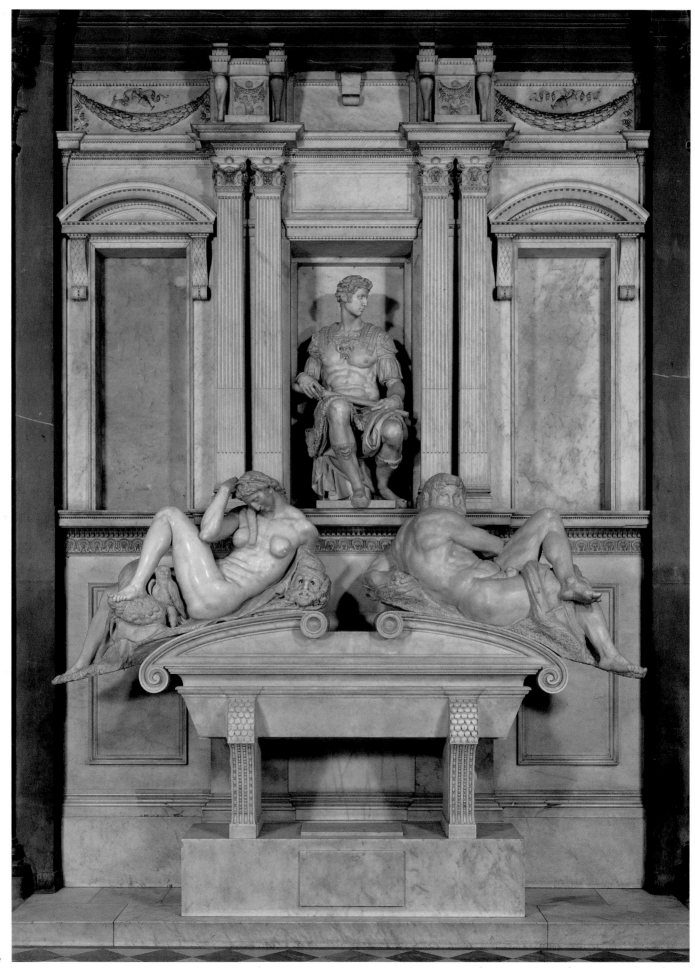

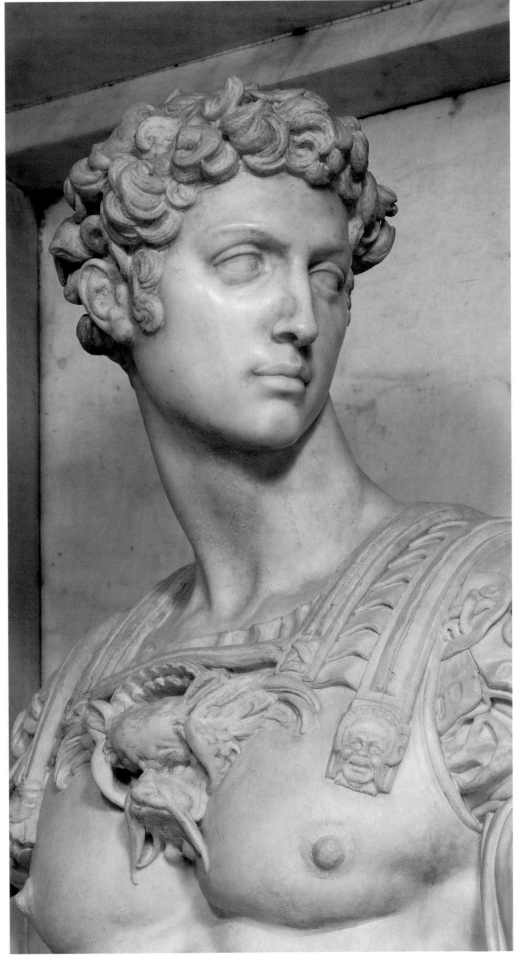

55

51

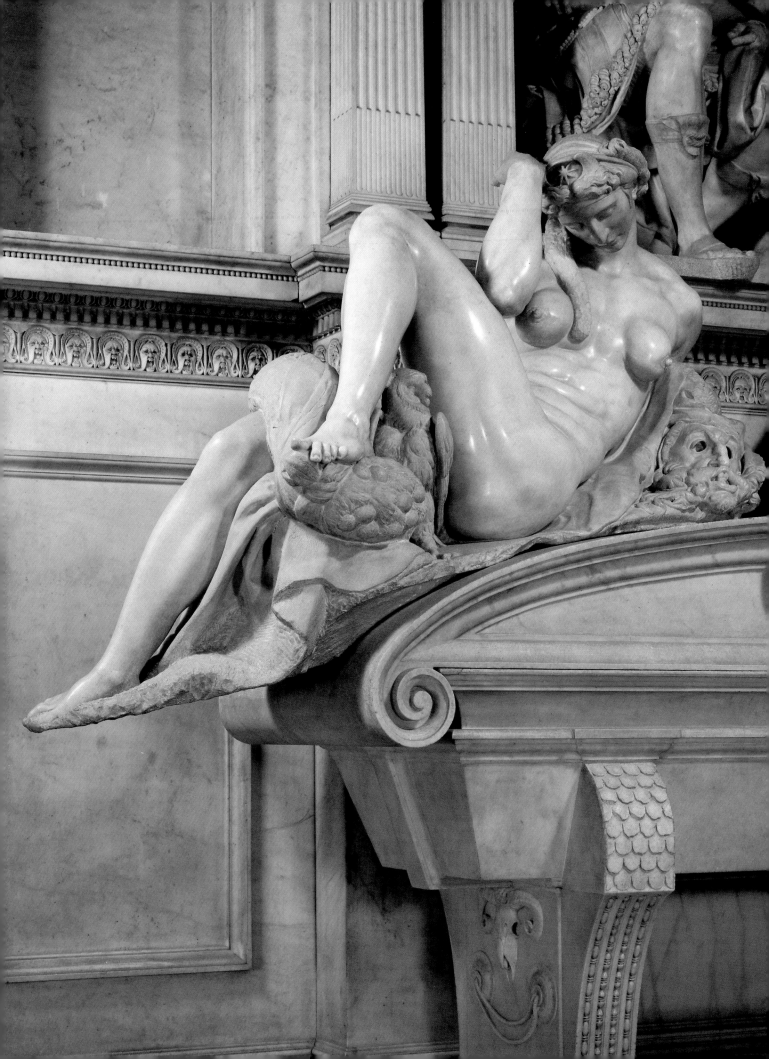

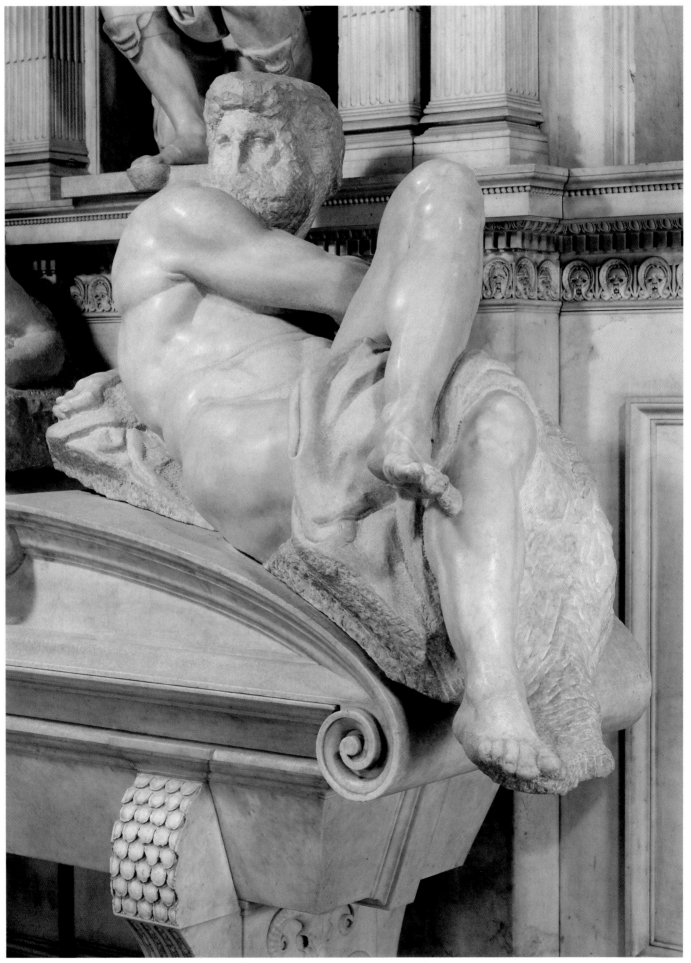

57

58

a disappointment to Michelangelo, that he never really became engrossed in this new task, whatever potential personal importance these tombs might have held for him.

The plans for the Chapel which we still have, show us that his Medici patron allowed Michelangelo a far greater freedom in this task than he was allowed by Julius II in the decoration of the Sistine Chapel. The artist planned the principal group of the Chapel, dedicated to the Resurrection, for the entrance wall; the *Madonna,* as the Lux Aeterna, was to stand above the tomb of the "Magnifici," with the two patron saints of the Medici family, Cosma and Damiano, on either side. Two figures of nude men should have lain at their feet, as personifications of *Rivers.* A representation of Christ's Resurrection had been planned for the lunette crowning the whole of this group. The two candelabra at the altar on the opposite wall represent the pelican as a symbol of self-sacrifice and the Phoenix as a symbol of Resurrection. The tombs of the Dukes on the side walls are highlighted by the faces of the Dukes turned towards the Madonna. The heavy figures of *Night* and *Day, Dawn* and *Twilight* lie on the sarcophagi underneath them. The lunettes above the tombs were to contain

58. New Sacristy with the tomb of Giuliano and the Madonna and Child

59. Reclining Adolescent
h. 54 cms.
Leningrad, Hermitage

54

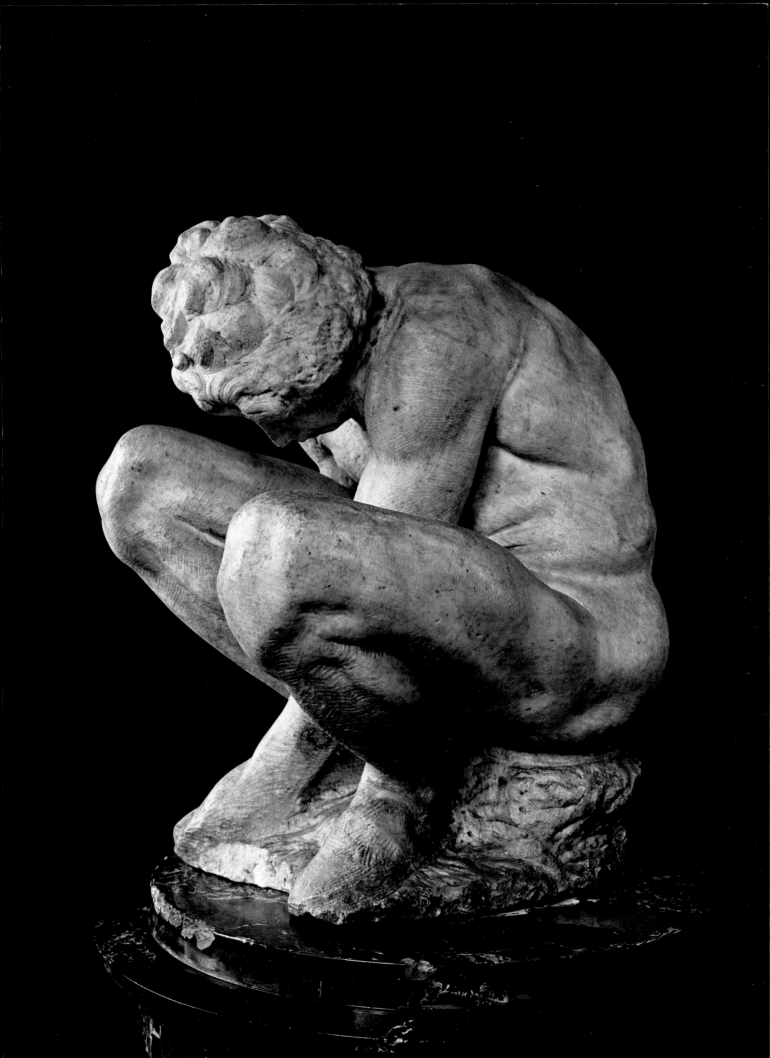

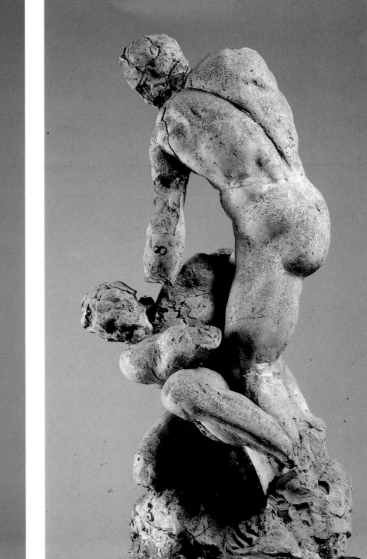

scenes from the *Old Testament*.

Not much of this vast plan was in fact carried out, yet it is enough to give us an idea of what Michelangelo's over-all conception must have been. Each of the Dukes' tombs is divided into two areas, and the border is well marked by a projecting cornice. In the lower part are the sarcophagi with the mortal remains of the Dukes, on which lie *Twilight* and *Dawn, Night* and *Day* as the symbol of the vanity of things. Above this temporal area, the nobility of the figures of the Dukes and the subtlety of the richly decorated architecture which surrounds them represent a higher sphere: the abode of the free and redeemed spirit.

The equal importance of the human figure and of architectural elements as means of expression show that Michelangelo had altered his conception of the world as he had expressed it in the ceiling of the Sistine Chapel. There, all the communica-

tion is in the figures: only man seems able to live and personify the highest spiritual experiences. But in the Medici Chapel, the whole "world" seems capable of the utmost beauty, even though it will never be the mortal world, to which we who enter the chapel belong, but it is a higher world, be it that of Christian Redemption or that of Platonic Ideals.

During his life Michelangelo had had the opportunity of knowing both these forms of the human spirit; the one in the Humanist circle of Lorenzo de' Medici, the other, albeit in an extreme form, through the religious teachings of Savonarola. The historical opposition of these forms had become a political topic in the struggle of Savonarola against the Medici; however, the blending of them does not seem to have afforded Michelangelo many difficulties, because his outlook was not so much intellectual, but rather artistic and emotional. In the figures of the *Madonna and Child* above the tomb 48

62

60, 61. Hercules and Cacus
h. 41 cms.
Florence, Casa Buonarroti

62. Study for the fortifications of Porta del Prato
Florence, Casa Buonarroti

63. Study for the head of a woman
Florence, Casa Buonarroti

63

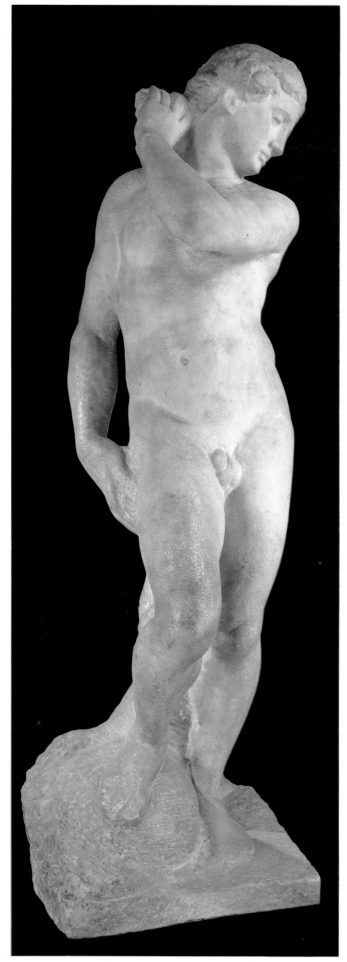

64. *David/Apollo*
h. 146 cms.
Florence, Museo Nazionale del Bargello

65. *David/Apollo, detail*
Florence, Museo Nazionale del Bargello

66. *Staircase of the Laurentian Library*
Florence

of the "Magnifici", there is but little human contact, despite their physical closeness: the most glorious of women is moved by the Child in the same way as by the contemplation of the highest Platonic thought, and this seems to transpire from her face.

In 1521, when Michelangelo began this statue, he had only just completed *Christ Carrying the* 47 *Cross* in the Church of Santa Maria Sopra Miner-va; in this work, as in the 1499 *Pietà*, he did not 12 portray pain as redemption in the medieval way, but perfect beauty as the expression of its consequence.

In 1530, the *David/Apollo* was commissioned 64 by the hated Papal Governor of Florence, Baccio Valori. Here Michelangelo used an entirely different approach: pragmatic and political. This figure has had its double name for a long time, since it

64

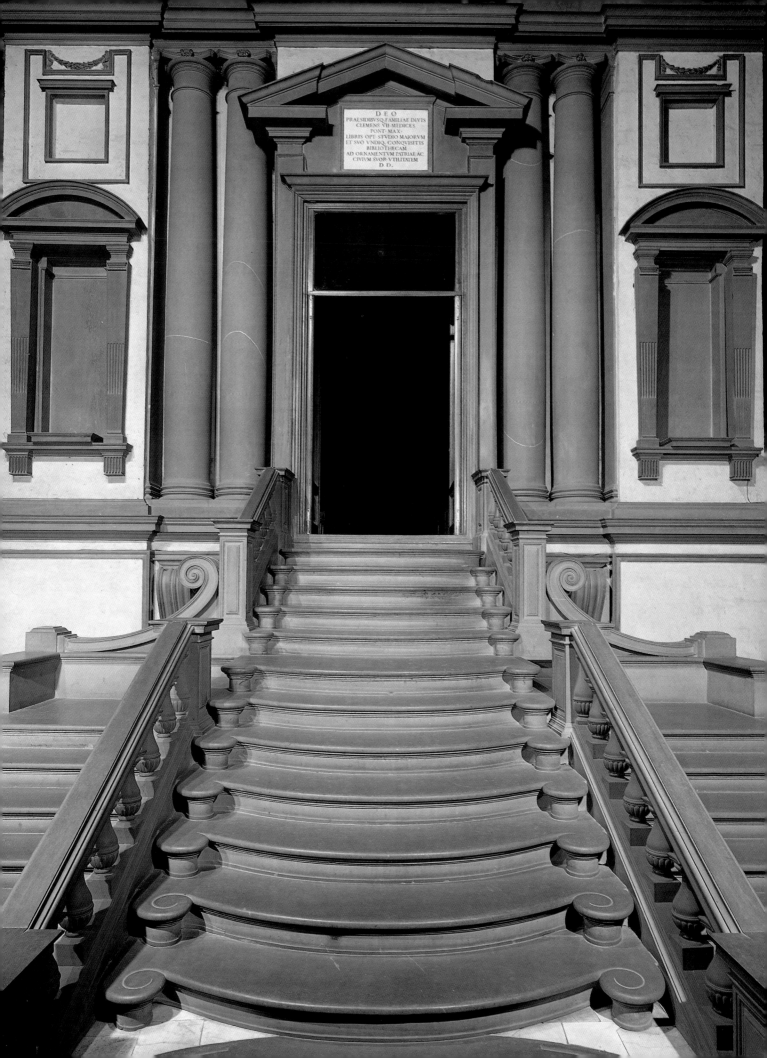

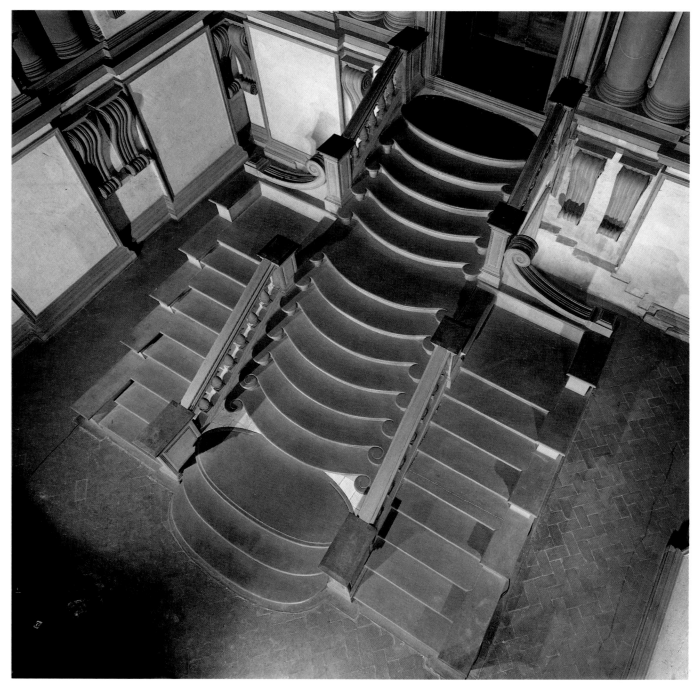

67

was not certain whether it was a representation of the Old Testament hero David or of the Greek God of Art, Apollo. But in the round rock under the youth's foot one can probably recognize the unfinished head of Goliath: so, once again Michelangelo has created a David. There is a blatant difference between this figure and the one which in 1504 rose to the position of the most powerful symbol of the Republic. In the place of Strength and Wrath, we have Melancholy, almost Regret. The victorious hero no longer celebrates his triumph; the blood that has been shed seems to have shown him the meaning of his actions and of its consequences. Michelangelo could not have admonished Baccio Valori in a deeper, more

20

67. The staircase of the Laurentian Library seen from above

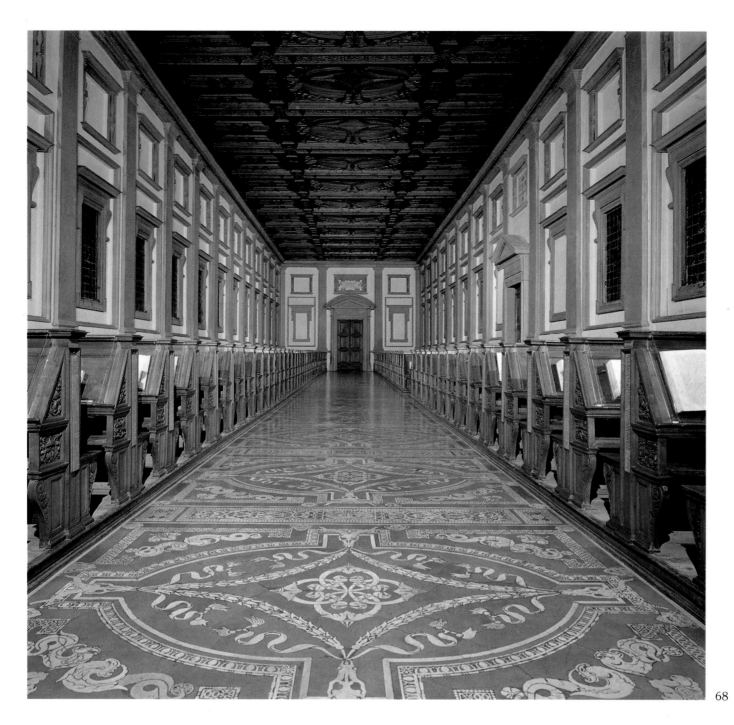

68

68. Laurentian Library
Florence

meaningful and yet more respectful way.

A task quite new in the history of art was entrusted to Michelangelo when the Medici asked him to build the *Laurentian Library*. At first this commission was given little opportunity of development, for the year 1526 marked, for the time being at any rate, the end of the Medici rule. Only four years later was the artist able to continue his work. The columns, deeply set in the walls, with their anthropomorphically gigantic appearance, and the organic élan of the staircase show that, even as an architect, Michelangelo never began from abstract geometrical laws, but only from the human body.

66-68

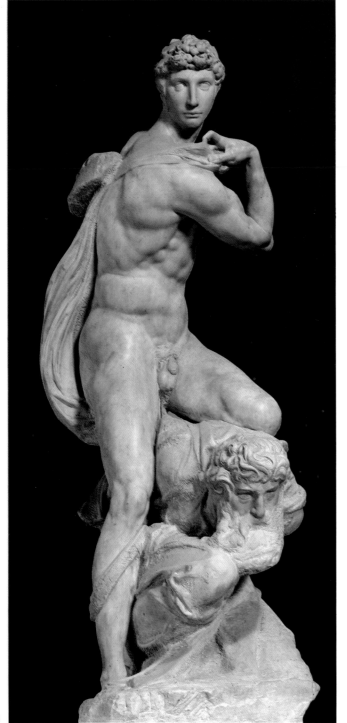

69

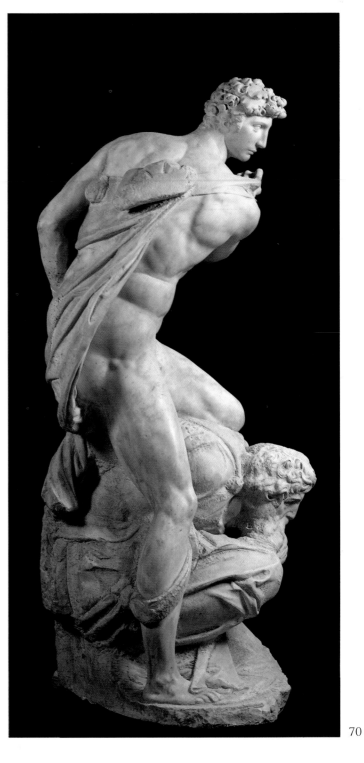

70

69, 70. Victory
h. 261 cms.
Florence, Palazzo Vecchio

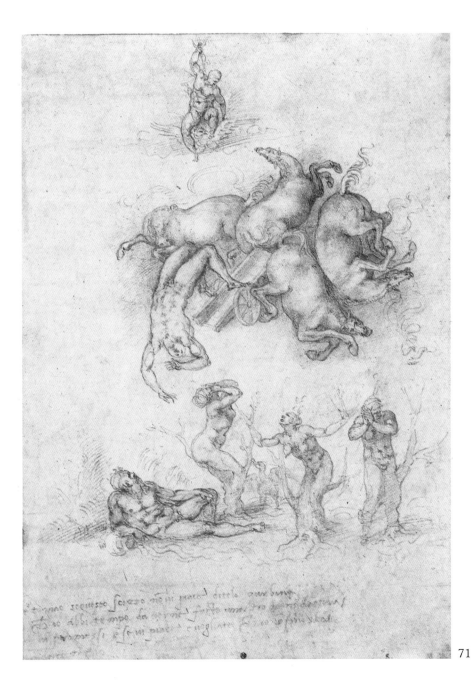

71

Transfer to Rome: 1534-1549

During a brief visit to Rome in 1532, Michelangelo met the young aristocrat Tommaso Cavalieri, whose beauty and nobility won his unconditional love, as is proved by many of his poems of that period. Cavalieri obtained from Michelangelo what the greatest men of the time asked for in vain. The artist prepared for him a series of drawings representing, among other things, *The Rape of* 71 *Ganymede* and *The Fall of Phaeton;* the first draught of the latter, now in London, both in its composition and the idea of the fatal power with which destiny takes its course, clearly 73 anticipates the fresco of the *Last Judgment.*

This fresco was commissioned by Pope Clement VII (1523-1534) shortly before his death. His successor, Paul III Farnese (1534-1549), forced Michelangelo to a rapid execution of this work, the largest single fresco of the century. The first impression we have when faced with the *Last Judgment* 73 is that of a truly universal event, at the centre of which stands the powerful figure of Christ. His raised right hand compels the figures on the lefthand side, who are trying to ascend, to be plunged down towards Charon and Minos, the Judge of the Underworld; while his left hand is drawing up the chosen people on his right in an

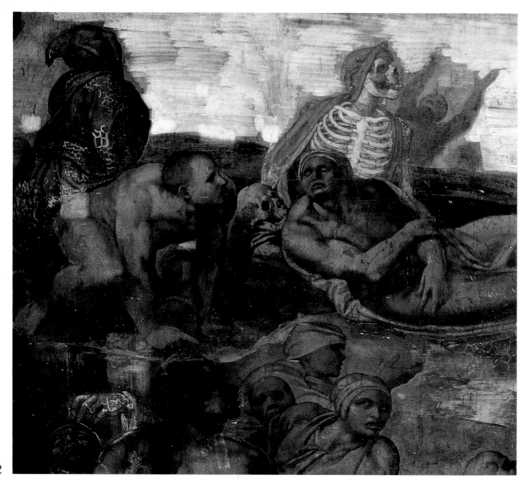

72

72

72. *Sistine Chapel*
Last Judgment
Detail of the
Resurrection of the
Dead
Vatican

73. *Sistine Chapel*
Last Judgment
Vatican

74. *Sistine Chapel*
Last Judgment
Detail of Charon
Vatican

75. *Sistine Chapel*
Last Judgment
Detail of the Damned
Vatican

irresistible current of strength. Together with the planets and the sun, the saints surround the Judge, confined into vast spacial orbits around Him. For this work Michelangelo did not choose one set point from which it should be viewed. The proportions of the figures and the size of the groups are determined, as in the Middle Ages, by their single absolute importance and not by their relative significance. For this reason, each figure preserves its own individuality and both the single figures and the groups need their own background.

The figures who, in the depths of the scene, are rising from their graves could well be part of the prophet Ezechiel's vision. Naked skeletons are covered with new flesh, men dead for immemorable lengths of time help each other to rise from the earth. For the representation of the place of eternal damnation, Michelangelo was clearly inspired by the lines of the *Divine Comedy*:

Charon the demon, with eyes of glowing coal
Beckoning them, collects them all,
Smites with his oar whoever lingers.

According to Vasari, the artist gave Minos, the Judge of the Souls, the semblance of the Pope's Master of Ceremonies, Biagio da Cesena, who had often complained to the Pope about the nudity of the painted figures. We know that many other figures, as well, are portraits of Michelangelo's contemporaries. The artist's self-portrait appears twice: in the flayed skin which Saint Bartholomew is carrying in his left-hand, and in the figure in the lower left hand corner, who is looking encouragingly at those rising from their graves. The artist could not have left us clearer evidence of his feeling towards life and of his highest ideals.

In 1538, three years before the completion of the *Last Judgment*, Michelangelo had met Vittoria Colonna. She belonged to the circle of Juan Valdès, who was striving towards an internal reform of the Catholic Church. To put it very simply, one can say that the main conviction of this theological trend was the idea of the utmost need of faith, as opposed to good deeds or sacraments, because, in the last resort, it is only divine grace which is all-powerful. These almost protestant beliefs could not conquer, or in any way change, Michelangelo because too much of his work would have had to be denied. However, they must have to some extent disrupted his firm belief, as he had expressed it in his works, that by creating perfect physical beauty he had represented the essence of the supernatural and of the divine. It is true,

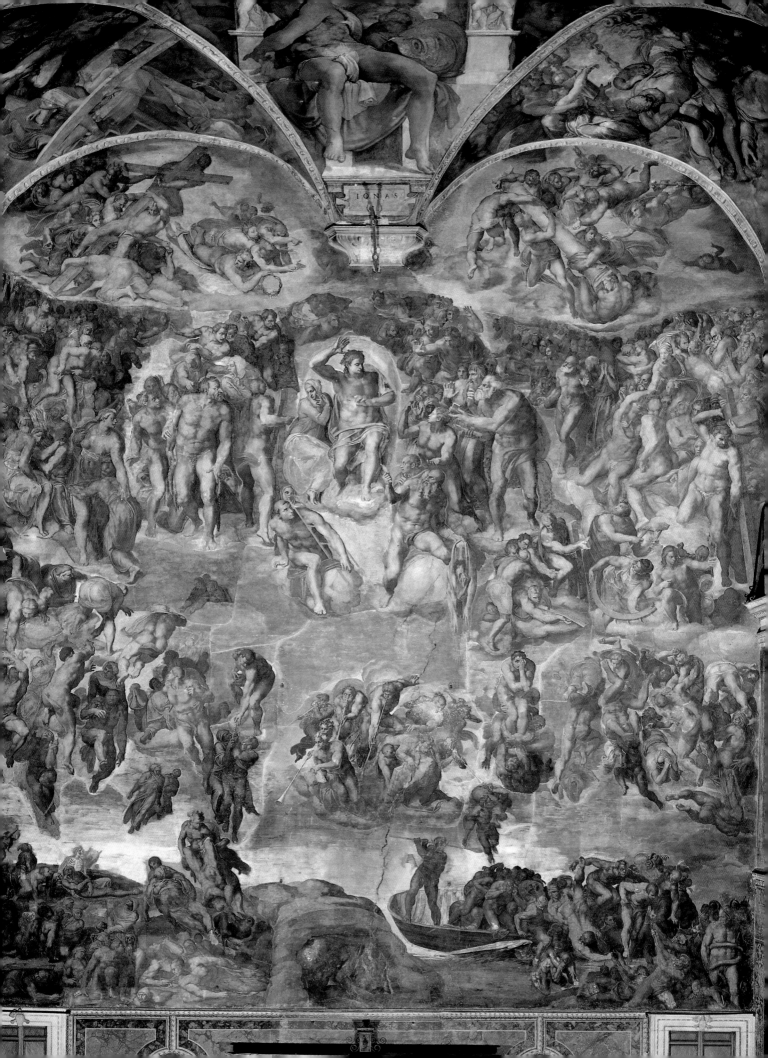

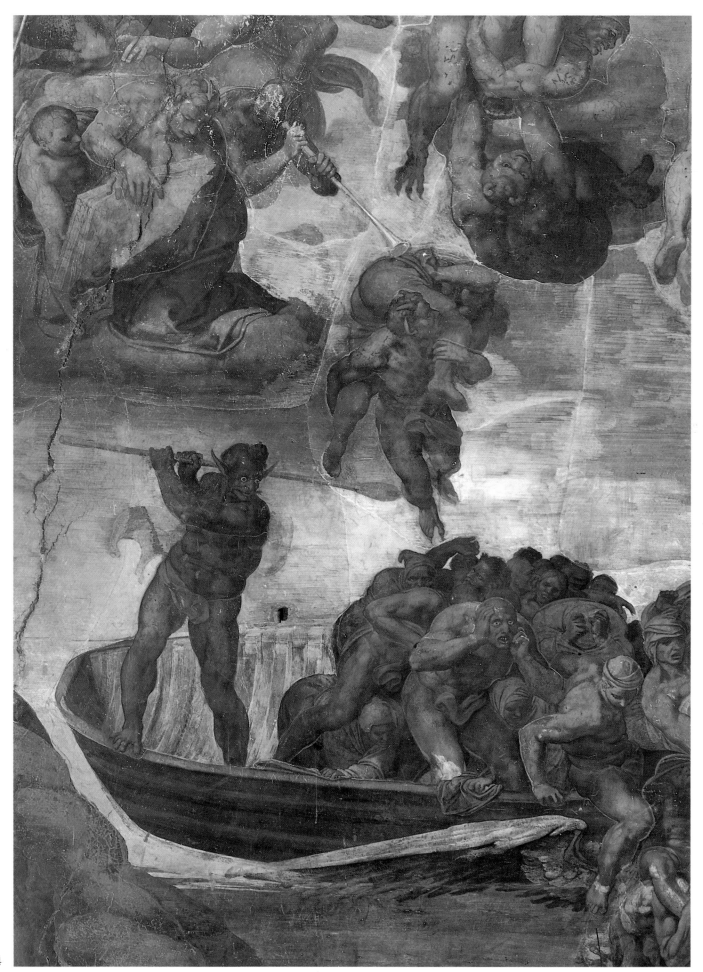

74

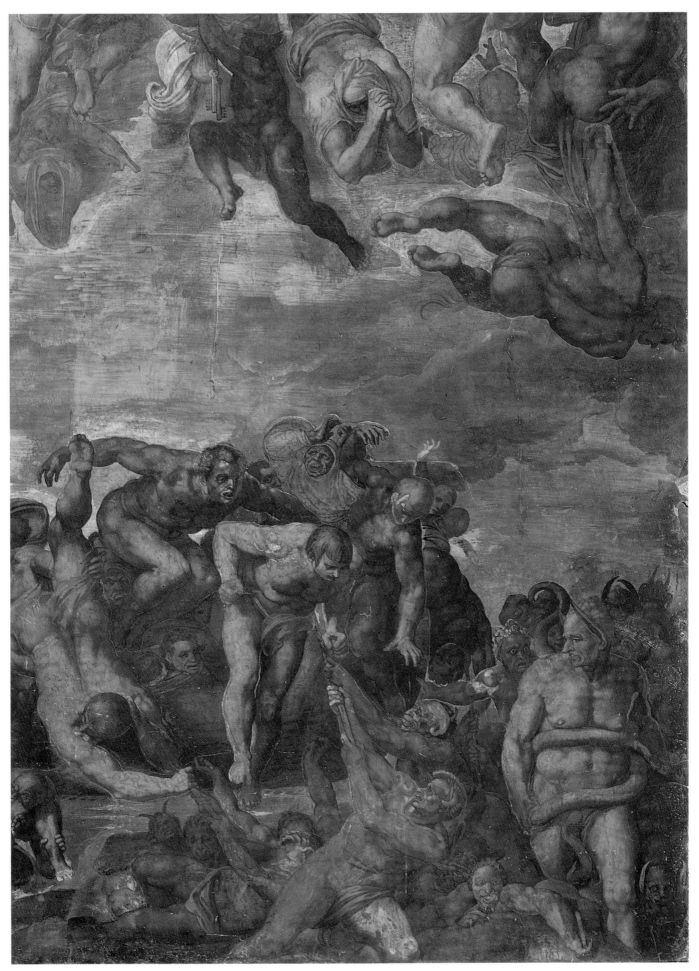

75

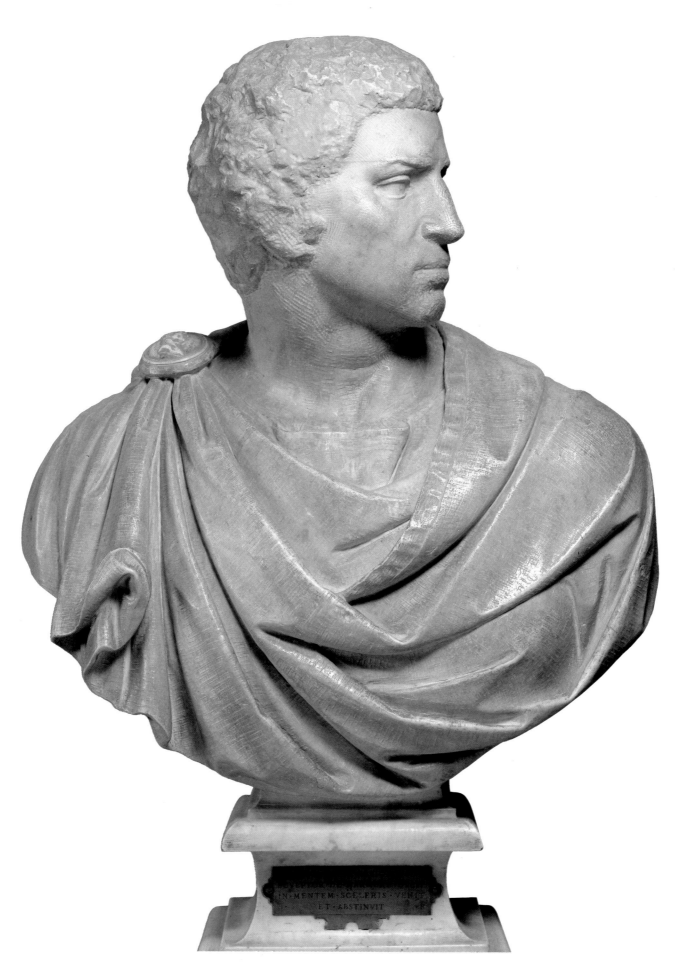

IN·MENTEM·SCELERIS·VENIT
ET·ABSTINVIT

76

76. Brutus
h. 95 cms.
Florence, Museo Nazionale del Bargello

77. Study for the Colonna Pietà
Boston, Isabella Stewart Gardner Museum

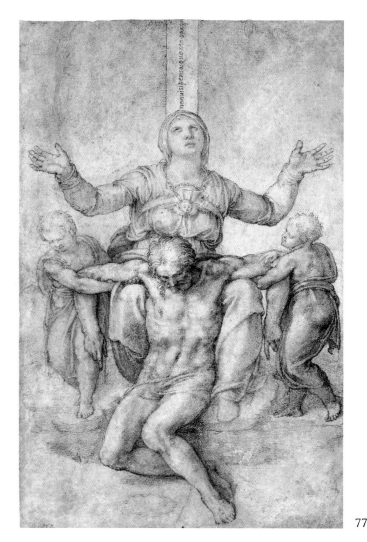

77

however, that he felt the need for divine grace, and, from this point onwards, this had great bearing on his creative life. We find evidence of this in a 77 drawing of the *Pietà*, made for Vittoria Colonna. 12 When compared with the 1499 *Pietà*, we see clearly that the main objective is the thought of the Compassionate Christ and of the Redemption through Christ's Blood. The work turns openly towards the onlooker to admonish him, drawing his attention to the sacrifice of Golgotha.

Perhaps Michelangelo's last work of primarily political significance should be dated to the same year as the drawing for it: 1540. This was the bust of 76 *Brutus*, which Michelangelo fashioned for Cardinal Niccolò Ridolfi, who, in 1530, had fled Florence for Rome like many other Florentines; although Michelangelo might well have been thinking of Lorenzino Medici, the well-known "Modern Brutus" who had killed Duke Alessandro de' Medici in 1537, this is clearly an idealized portrait of the patron. In the head, which shows strength of will in the way it is turned to the right, a cold tranquillity and great energy blend fascinatingly with hatred, wrath and bitter contempt.

The date for the completion of Julius II's tomb

(1532) had already passed when yet another contract for another altered plan, which had to be executed in the course of the following three years and in the agreed way, was signed in 1542. By this time converted to new beliefs, Michelangelo was allowed to do away with even the last two slaves. In their stead he created two new statues: *Rachel*, 80 the symbol of contemplative life, and *Leah*, the 81 symbol of active life. In this work we see that his original idea of the structure of the Christian world had, in 40 years, undergone a profound change; it had become a religious monument with Moses, the predecessor of Peter and all Popes in the middle, and supported on either side by the personifications of Faith (*Rachel*) and of Active Love (*Leah*).

Between 1537 and 1540, Antonio da Sangallo the Younger built the Pauline Chapel in the Vatican, as the Pope's private chapel. In 1541, Michelangelo was asked to decorate the central parts of the two longer walls with two frescoes. The first, *The Conversion of Saint Paul*, was begun in 86 1542; the second, the *Martyrdom of Saint* 87 *Peter*, was painted between 1546 and 1550. Before this, no one had ever attempted to place these two themes next to each other. In fact, the

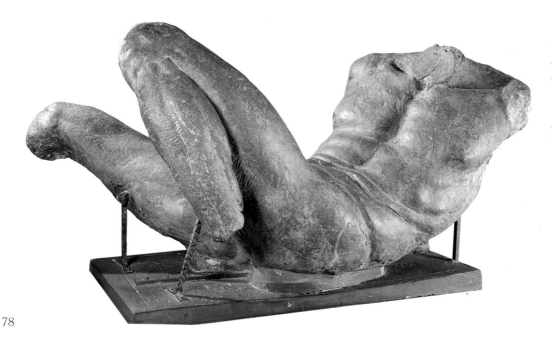

78

first edition of Vasari's *Lives* (1550) says that Michelangelo would paint, as a counterpart to the *Conversion*, the *Giving of the Keys*. According to the figurative traditions of the time, this subject would have been far more logical, but Michelangelo portrays what is by this time his plan of life: death

for the faith must follow conversion and be its confirmation. To Paul, who has fallen and has been forced to shut his eyes because of the brilliance of divine light, he gives his own face and makes Peter, nailed to the cross, in the supreme tension of the last moment of life, forcefully look at the spectator.

During these years the artist was given the most important architectural tasks of his career. In Rome he completed for the Pope the third storey, looking on to the courtyard, and the cornice, of the *Palazzo Farnese* and, still for Paul III, planned the remodelling of the Campidoglio, which was executed only years later. But his nomination to the post of Chief Architect of *Saint Peter's* was undoubtedly the most important task for Michelangelo, so important that it prevented him from returning to Florence before his death. Despite the doubts he had had, he took up Bramante's original plan of a central building, after the new construction had begun in 1505, but he simplified it in accordance with his own development since the beginning of the century. This one can outline in his works through the different plans for Julius II's tomb. Before 1564, the date of Michelangelo's death, only the drum of the dome with its gigantic and monumental row of double columns, so vital to the effect the building makes to the general view of the city, was completed.

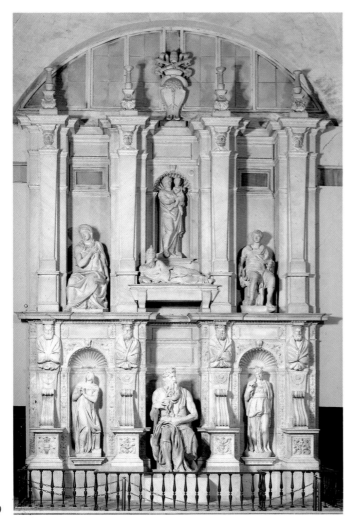

79

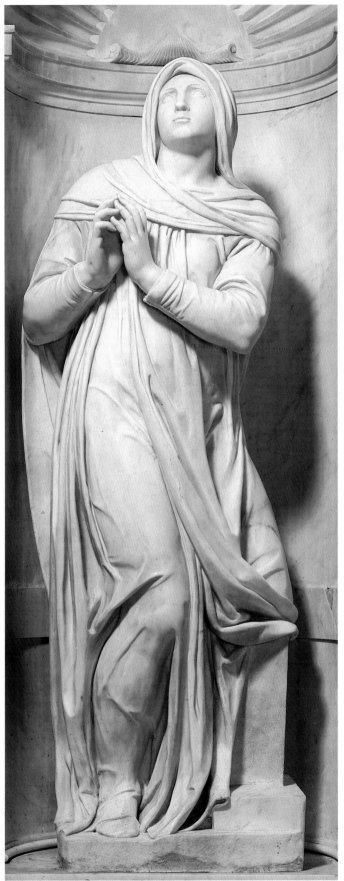

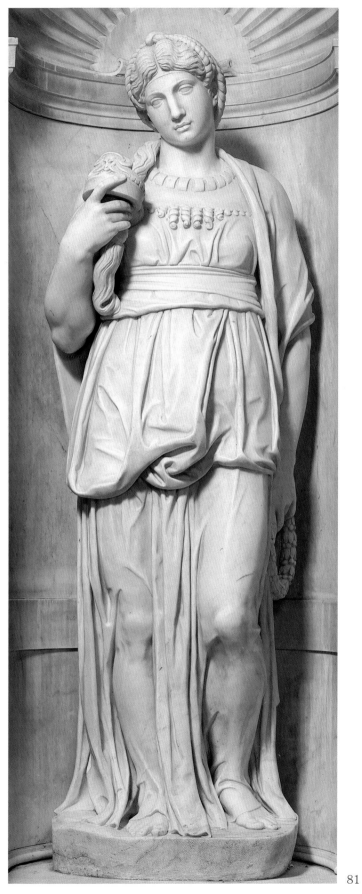

80. Tomb of Julius II
Detail of Rachel
Rome, San Pietro in Vincoli

81. Tomb of Julius II
Detail of Leah
Rome, San Pietro in Vincoli

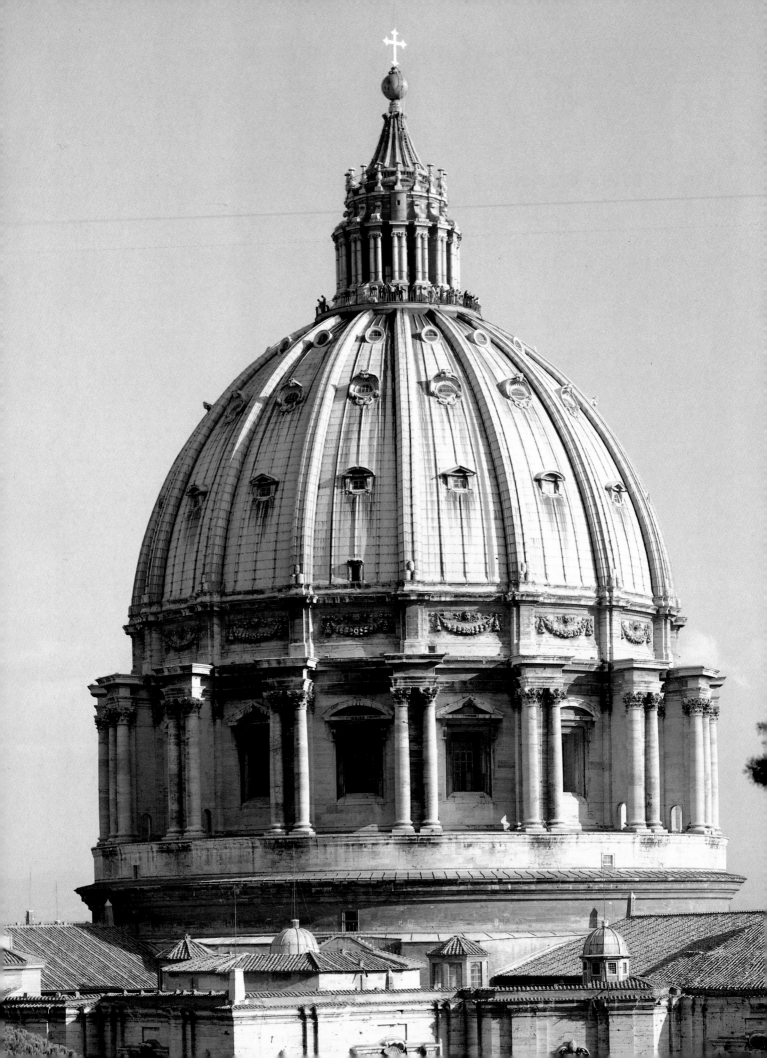

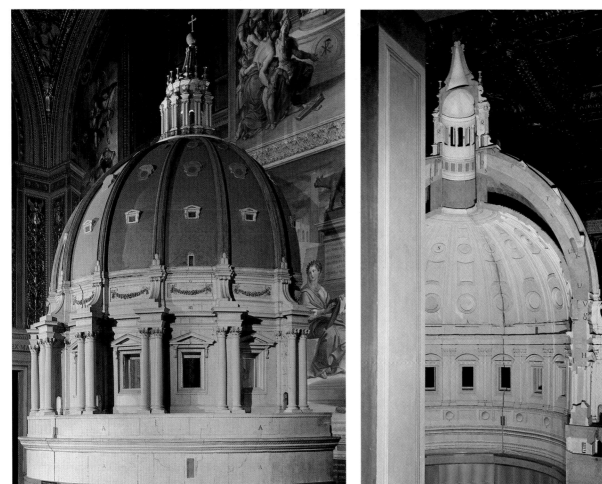

83

84

82. The dome of
St. Peter's
Vatican

83. Original wood
model for the dome of
St. Peter's
Vatican Museums

84. Section of the
wood model for the
dome of St. Peter's
Vatican Museums

85. Interior of the
dome of St. Peter's
Vatican

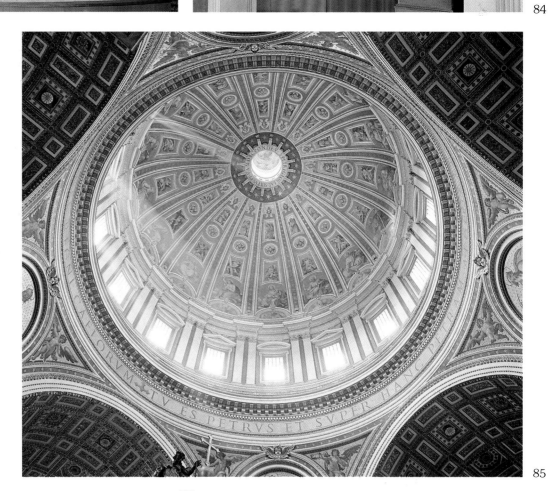

85

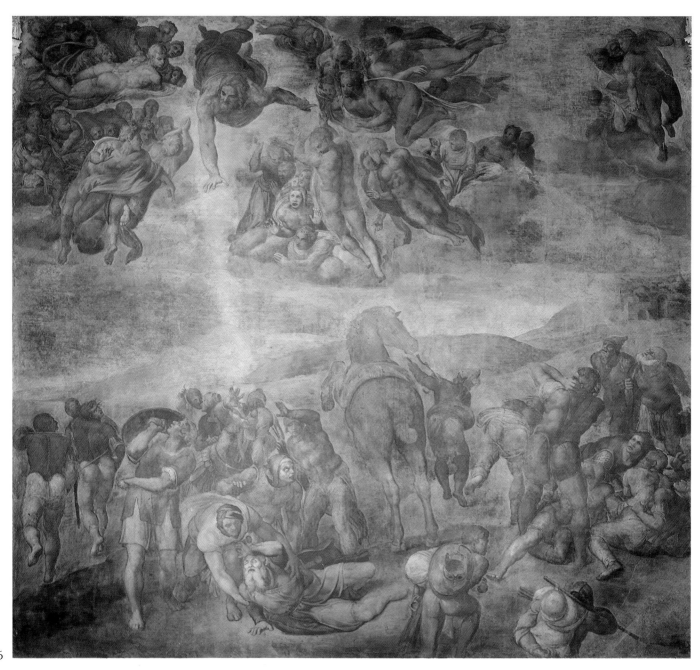

86

The late period: 1549-1564

After he had been converted, under the influence of Vittoria Colonna, death became a dominant theme in Michelangelo's poetry. Even his last sculptures — two or three Pietàs — deal with this theme, and some of them were probably planned to decorate his tomb. According to Vasari, the artist's wish was to be buried in Santa Maria Maggiore in Rome, at the feet of the *Pietà* on which he had 88 worked between 1547 and 1553; this was before he smashed it in 1555, because one leg had broken off and because the block of marble was defective. This *Pietà*, which is now in the Cathedral of Flor-

ence, was begun the year of Vittoria Colonna's death. After having broken the statue, he let his servant take the pieces. Later the servant sold them and the new owner had it reconstructed following Michelangelo's models, so that the work has been preserved for us.

Michelangelo, in this *Pietà*, did not portray any precise historical moment; instead he erected a personal admonishment to himself, "One does not think how much blood it costs." He had once written this line, from the *Divine Comedy*, on the drawing for the *Pietà* which he did for Vittoria Colon- 77

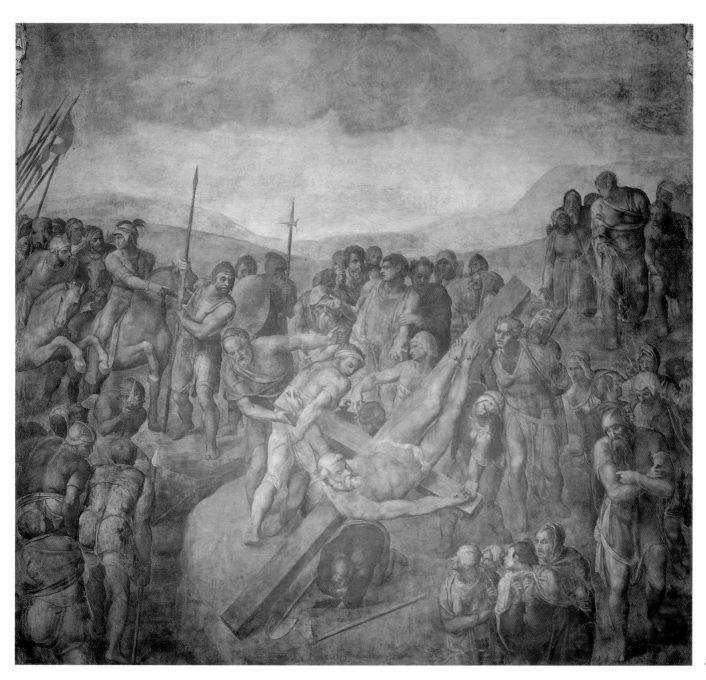

*86. Conversion of Saint Paul
Vatican, Pauline Chapel*

*87. Crucifixion of Saint Peter
Vatican, Pauline Chapel*

na, and from the composition of this drawing he took this marble group. Nicodemus has taken the place of the Madonna and she, with Mary Magdalen now does what the angels did, supports the body. There is no longer only the Mother, but three people are now surrounding the Body, and Christ's "deadness" is expressed more effectively by the falling movement in which he is caught halfway. The figures are not isolated from the emaciated dead body: they are blended, in their fear, desperation and pain, into a single setting. The bodies are denied any independent power and there is nothing, like the Madonna's act of prayer in the drawing for Vittoria Colonna, to point to a higher meaning of this suffering, such as redemption.

About half a century separates this work from the *Pietà* in Saint Peter's: almost fifty years of ar- 12

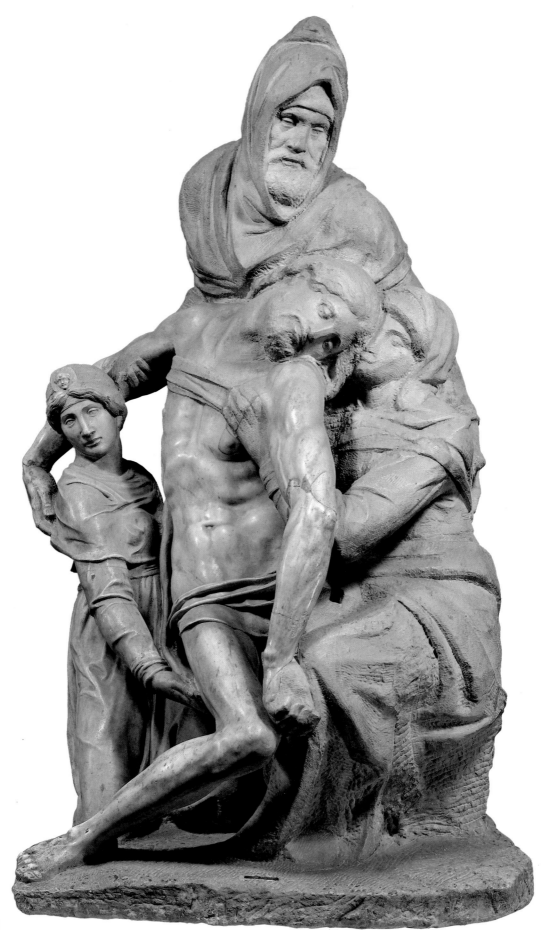

88

88. Pietà
h. 226 cms.
Florence, Opera del
Duomo

89. Palestrina Pietà
h. 253 cms.
Florence, Galleria
dell'Accademia

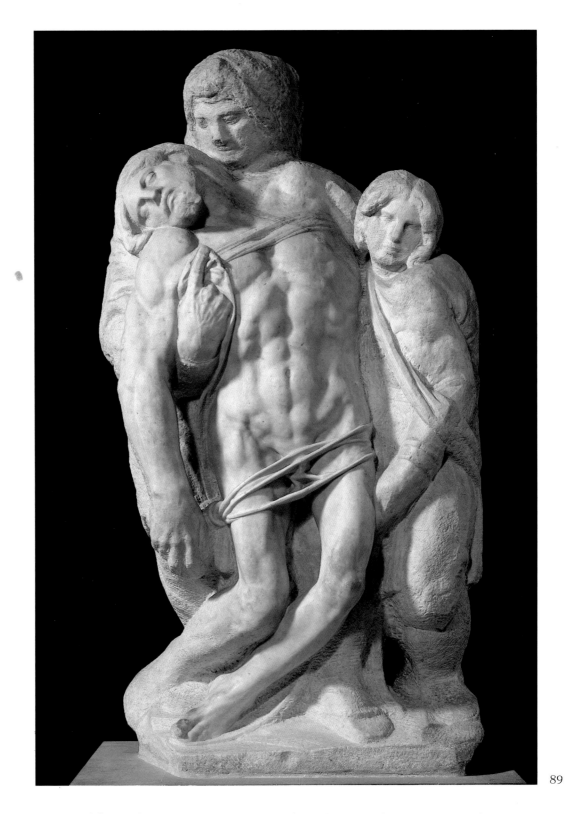

89

tistic evolution are here recognizable in their extreme poles. But this also marks the development undergone by the whole of European culture: from the Renaissance, from the revival of Antiquity and the rediscovery of nature, to the splitting up of the Christian Church, the return of faith after the Counter Reformation and the Manneristic art of an El Greco. Only the figures of this Spanish artist, glowing signs of faith, can in some way be compared to the work which Michelangelo fashioned up to six days before his death. This was the *Pietà Rondanini*, which, according to Vasari, he had already begun in 1555, before smashing the Florentine Pietà. He destroyed the first version of this too, as can be seen in the second face of Christ in the final version. This version, still unfinished at the artist's death, was probably begun not much later than 1555. The unity between Mother and Son is even more intimate. It is almost impossible to tell whether it is the Mother supporting the Son, or the Son sup-

90

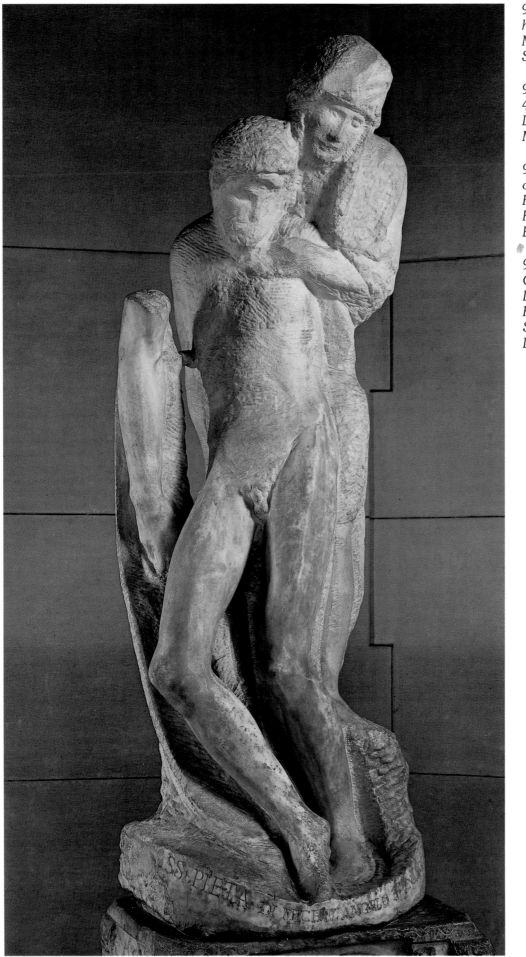

90

*90. Rondanini Pietà
h. 195 cms.
Milan, Castello
Sforzesco*

*91. Crucifix
41.2 × 27.9 cms.
London, British
Museum*

*92. Plan for the church
of San Giovanni dei
Fiorentini
Florence, Casa
Buonarroti*

*93. Tomb of
Giuliano de' Medici
Detail of the mask
Florence, New
Sacristy of San
Lorenzo*

porting the Mother, overcome by despair. Both are in need of help, and both hold themselves up in the act of invocation and lament before the world and God.

89 The so-called *Pietà Palestrina* was attributed to Michelangelo for the first time in 1756 without any proven evidence. If it were his, it would have to be placed between the two Pietàs, but the heaviness of the figures and the square contours of the group make this attribution improbable.

 During the last ten years Michelangelo mainly drew plans for new buildings and perhaps for further sculpture. After his reconciliation with Cosi-
92 mo de' Medici, he designed new plans for *San Giovanni dei Fiorentini.* He had also been attracted to the Jesuit order by their zeal and eagerness and offered to help them without payment in constructing their church, *Il Gesù.* He planned for Pope Pius IV (1559-1565) new gates for the city of Rome, of which only the *Porta Pia* was, in fact, built. In 1563 he began to direct the transformation of the Baths of Diocletian into a Catholic church, Santa Maria degli Angeli. But the drawings he did for his own personal use show us better than any of these other works something of the artist's development during these years. The last
91 of the six drawings of *Crucifixions* is probably to be dated to 1556. This shows us, once again, those same ideas which had tormented the artist during
90 his work on the *Pietà Rondanini:* "Oh! Flesh, Blood and Wood, supreme pain, Through you must I suffer my agony." These lines, which the artist had written at the age of 57, seem to convey the dominant feeling in the Madonna and Saint John, gathered around the Cross. Fear and pain have drawn the Madonna to Christ's body, while St. John turns towards Him in supplication, with one arm around the Cross. In this female figure there is nothing of the Mother of God represented in his
12 1499 *Pietà,* nor does the Evangelist recall anything
23 of the 1505 *St. Matthew.* Nowhere are the changes of this half century so clearly demonstrated as in the life and work of Michelangelo Buonarroti.

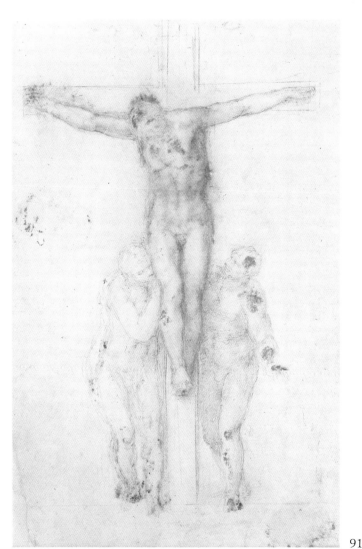

91

92

Short Bibliography

G. VASARI — *La vita di Michelangelo,* 1550 & 1568 editions, ed. P. Barocchi I, Milano-Napoli, 1962.

A. CONDIVI — *Vita di Michelangelo Buonarroti,* Roma 1553.

G. MILANESI — *Le lettere di Michelangelo Buonarroti,* Firenze 1875.

K. FREY — *Die Dichtungen des Michelangelo Buonarroti,* Berlin 1897.

C. JUSTI — *Michelangelo,* Leipzig 1900 and Berlin 1909.

K. FREY — *Die Handzeichnungen des Michelangelo Buonarroti,* Berlin 1909-11.

H. THODE — *Michelangelo und das Ende der Renaissance,* Berlin 1902-13.

E. STEINMANN, R. WITTKOWER, *Michelangelo-Bibliographie 1510-1926,* Leipzig 1927.

CH. DE TOLNAY — *Michelangelo,* Princeton 1943-60.

H. VON EINEM — *Michelangelo,* Stuttgart 1959.

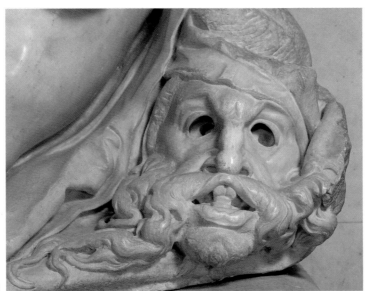